THE LOWCOUNTRY COLORING BOOK

BY MELISSA CONROY

ALGONQUIN BOOKS OF CHAPEL HILL 2016

Published by
Algonquin Books of Chapel Hill
Post Office Box 2225
Chapel Hill, North Carolina 27515-2225

a division of
Workman Publishing
225 Varick Street
New York, New York 10014

Printed in China
Published simultaneously in Canada by Thomas Allen & Son Limited.
Design by John Passineau

10 9 8 7 6 5 4 3 2 1
First Edition

This book is dedicated to my mom, Barbara Conroy.

INTRODUCTION

I was born in Beaufort, South Carolina, a place I consider to be the epicenter of the Lowcountry. Those born in Bluffton, Charleston, or Yemassee may disagree. But they were not introduced to the sights, smells, and colors of the world on Hancock Street in Beaufort's historic neighborhood, the Point. On Hancock Street, I combed my fingers through curly Spanish moss and made mud pies from the rich soil. On the waterfront, I squished my toes in silky marsh mud and cut my feet on oyster shells. For more adventure, we would drive over the Woods Memorial Bridge in Beaufort's historic downtown to Sea Island Parkway, where the Sea Islands unfold one after the other. Our destination was often Hunting Island to swim in the waves with a view of the maritime forest. Low tide at Hunting would leave tidal pools filled with sea life. I've seen bonnethead sharks, starfish, jellyfish, and stingrays in those tidal pools. On Fripp Island, my sisters and I would jump in a rowboat and search for alligators in the lagoon behind my dad's beach house. A stop at Shrimp Shack on St. Helena Island was always a must on the ride home for the world's greatest shrimp burger.

For city life, we would hop in the car for a forty-five minute drive south to Savannah, Georgia. Savannah offered historic squares adorned with sculptures and bordered by stately homes. Lunch was usually at the Crystal Beer Parlor. Sometimes we would eat at my parents' favorite Jewish deli, where my mom would save the pickle for dessert. For a bigger trip, we'd drive an hour and a half north to Charleston, South Carolina. In the French Quarter, we'd explore cobblestone streets, decorative wrought iron gates, and elegant buildings.

Now that I live in Philadelphia, I take comfort in knowing that when I visit the Lowcountry, so many constants wait there for me. Snowy white egrets gather in tree branches above the marsh at feeding time. Tiny fiddler crabs scuttle out of perfectly round marsh holes at low tide to battle one another with their oversized claws. Shrimp boats trawl the ocean to gather the little crustaceans. An

abundance of deer roam the forests of Fripp Island. Nature offers up any number of surprises, from the lumpy, unidentifiable sea creatures that wash up on the beach to the nest of dozens of baby alligators in the lagoon by the golf course on Fripp Island.

Near Frogmore, South Carolina, is Penn Center, home to the Historic Penn School Campus, the first school for freed slaves in the Sea Islands. Were it not for Penn Center, St. Helena Island and perhaps the rest of America would be a very different place today. Penn Center became a meeting place for people of all races during the civil rights movement. My mom tells me that one morning, in the 1960s, she saw a picture in the *Beaufort Gazette* of Martin Luther King Jr. at Penn Center with the heading "Martin Luther King at Communist Training School." How things have changed. Today, the road to Penn Center is named after Dr. King.

St. Helena Island is home to the descendants of the freed men and women the Penn School was set up to teach. They are the Gullah people, who developed a unique culture reaching back to West Africa and cultivated from years of living on the Sea Islands. Many Gullah traditions have been adopted by others in the area, like the placement of blue bottles on tree limbs. The thought is that if you place bottles on a tree's limbs, bad spirits will climb inside for shelter and find it impossible to escape.

On the Sea Islands, homes are traditionally built out of timber and placed upon pilings to protect them from the high water table. Some homes are lucky enough to have a live oak tree nearby. These large, muscular trees can be seen throughout the Lowcountry, ornamenting the streets, parks, and yards of towns, cities, and rural areas. Some of the live oak trees predate the towns themselves by up to a thousand years. The trees, a canopy of green accented by silver, draping Spanish moss, supply necessary protection from the strong Lowcountry sun.

In the Lowcountry, there are weathered layers to every manmade surface. Those who are near the ocean and marshland experience a daily metamorphosis thanks to the changing tides. The place is ancient yet always regenerating. Every

time I visit the beach and forest of Hunting Island, I feel as if I have stepped into a Jurassic landscape. It would not feel out of place to see a stegosaurus munching on a palmetto frond. Instead, what we see are the green marble eyes of alligators peering just above the surface of lagoons, waiting patiently for prey. There's something about the climate and landscape that is accommodating to creatures who share their ancestry with dinosaurs. The marsh and lagoons have always reminded me of primordial soup, and like primordial soup, the landscape is fertile.

On the Sea Islands, one must be prepared for the changing tides. The daily rise and fall of the Atlantic Ocean is extreme. She will drain marshland down to silky mud at low tide and then fill it up again high enough for large boats to easily navigate the streams that run through the stiff marsh grass. The tide will consume hundreds of yards of sandy beaches, in some cases devouring a beach altogether before restoring it to a pristine, habitable condition at low tide. Danger and beauty have a distinct way of coexisting in the Lowcountry.

The unique approach to the drawings in this coloring book draws inspiration from the coming and going of the tides and the daily metamorphosis that they cause in the Lowcountry. Like the fertile landscape of the Lowcountry, the drawings in this book have the potential for growth. Spreads can be removed from the book and combined into groups of four drawings at a time to create a larger work of art with seamless edges. As a collaborator in the final work of art, you have the option of rearranging the drawings into a new image. There are four possibilities with each group of four drawings.

The drawings in this book are by no means a comprehensive exploration of the area. If anything, I would say we are barely scratching the surface of a place so rich in culture, heritage, and landscape. All the same, I hope that the places in this book will inspire you to explore and discover your own Lowcountry landscape. The colors are entirely up to you.

— *Melissa Conroy*

THE CASTLE

BEAUFORT, SOUTH CAROLINA

"The Castle," a private home in a neighborhood called the Point, has many stories to tell. She was used as a military hospital during the Civil War, and the names of patients can still be seen written on some of the upstairs walls. Some believe the Castle is haunted by a dwarf jester named Gauche, who arrived with a band of French explorers in 1562. Can you find him?

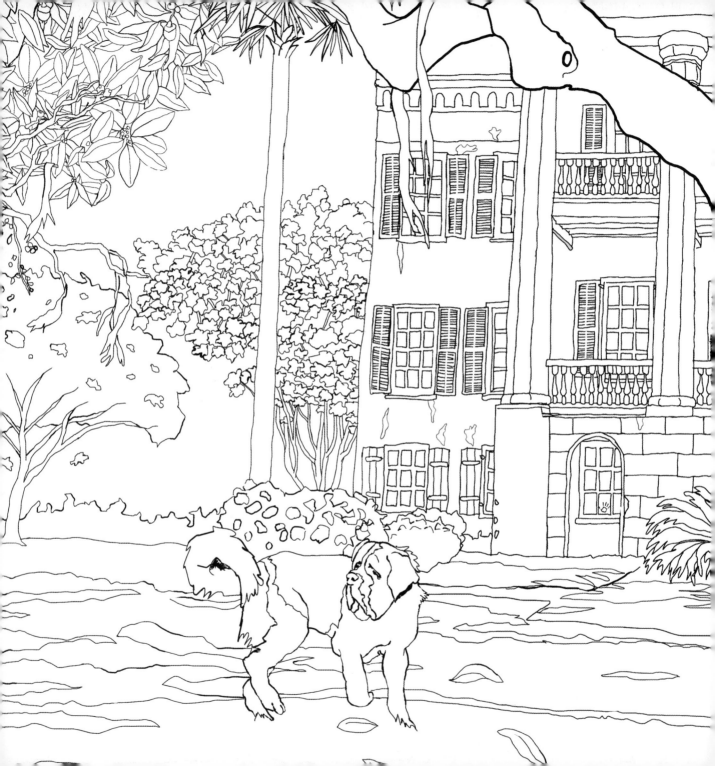

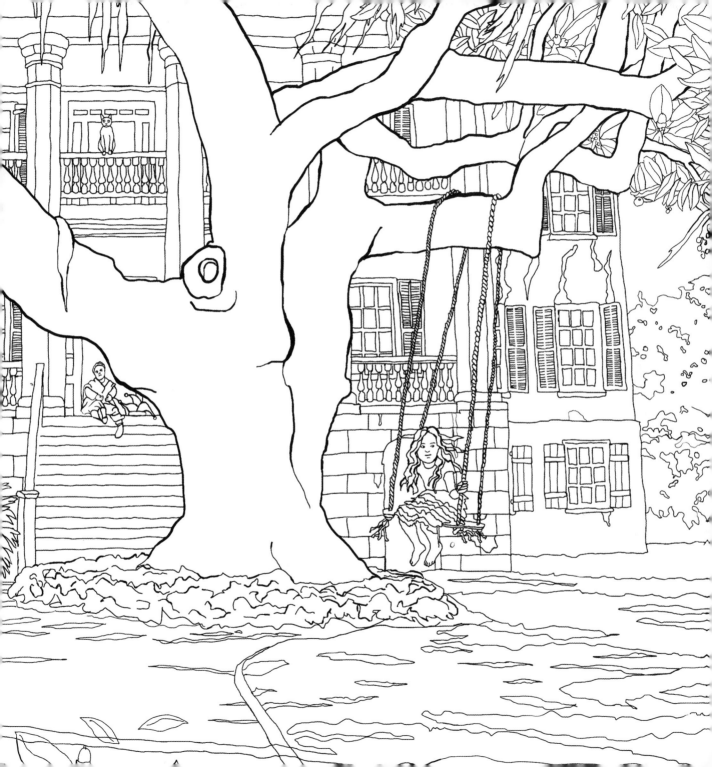

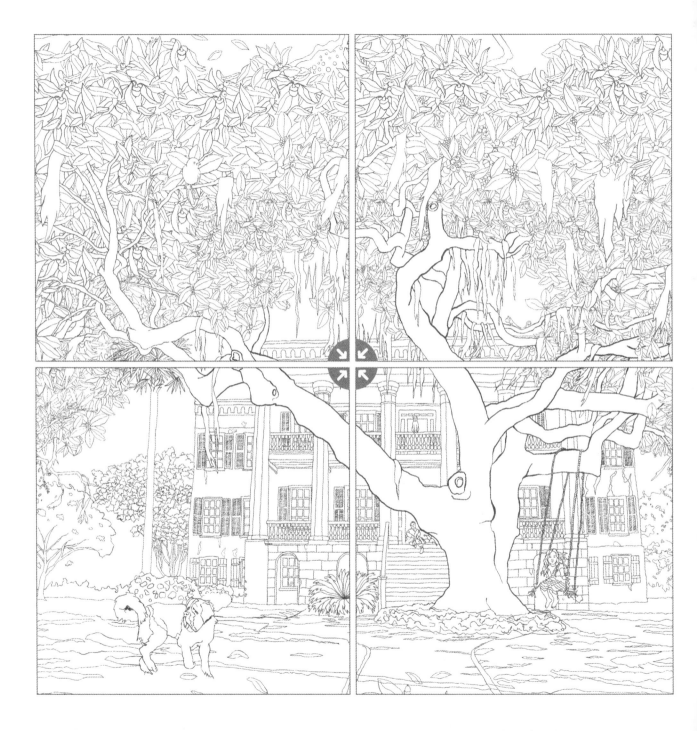

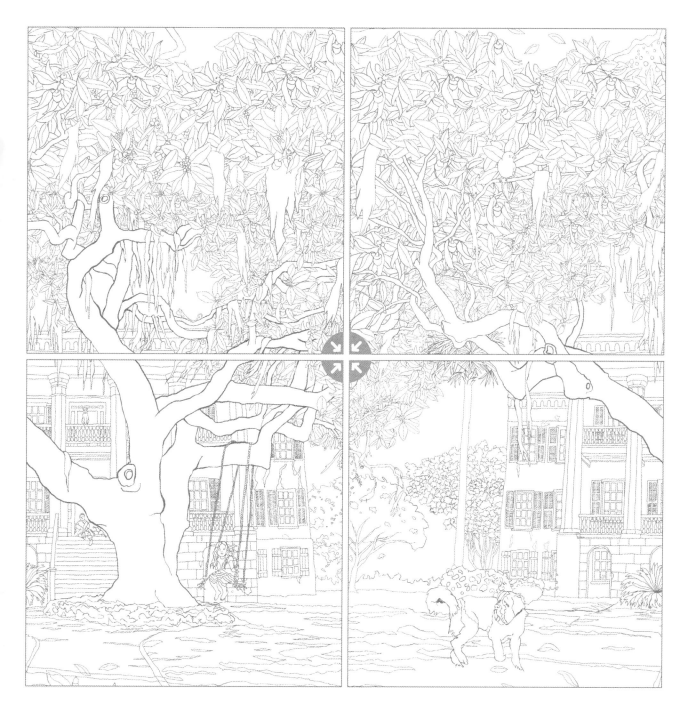

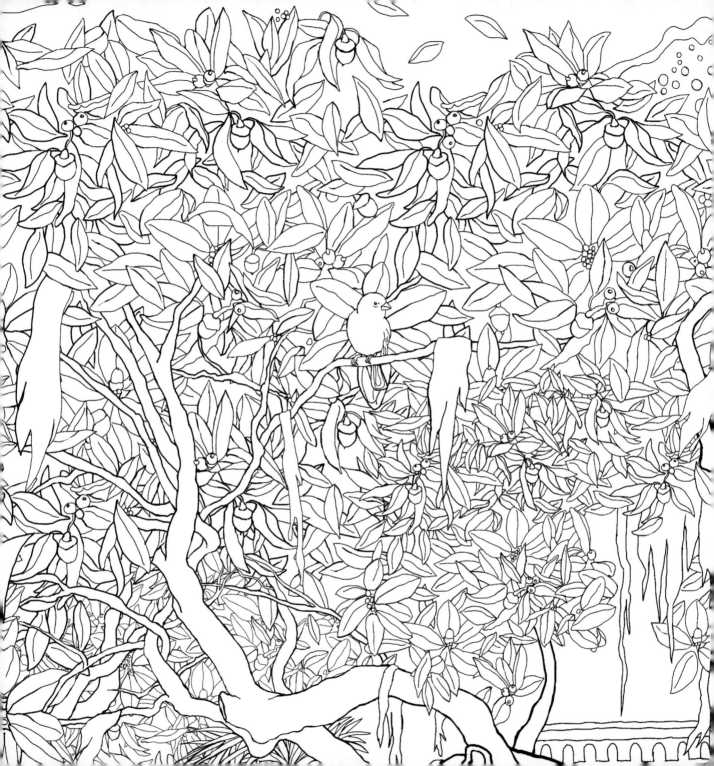

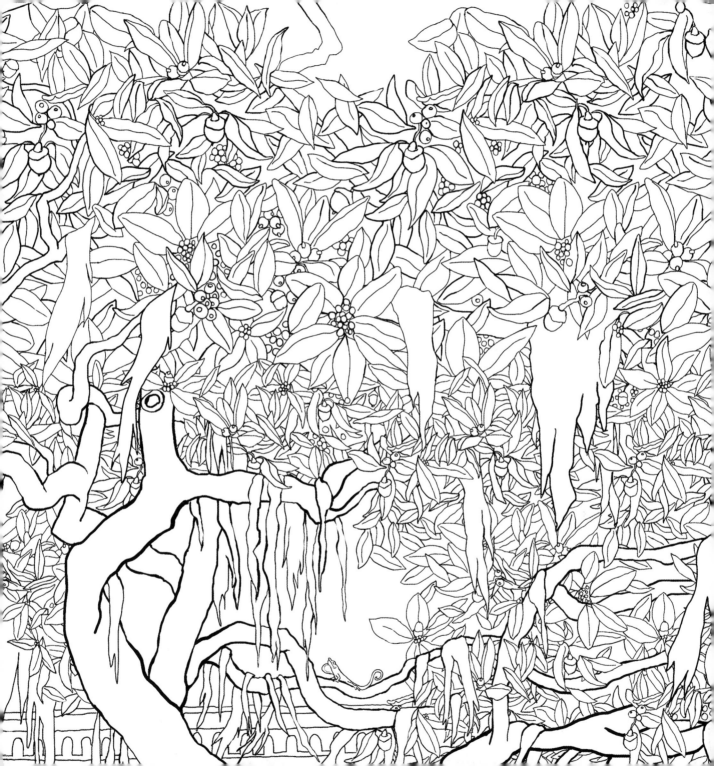

HUNTING ISLAND STATE PARK

SOUTH CAROLINA

On Hunting Island it is important to pay attention to the changing tides. Every season, more sand is swallowed up by the ocean and deposited elsewhere. Trees have been swept away. Most of the cottages that once sat near the south beach have disappeared, having been pulled out to sea. Only one remains. The Atlantic Ocean is coming to claim what is hers. But the birds will continue to fly and find trees for nesting. The palmetto trees will continue to grow, and as long as the lagoons are there, the alligators will thrive.

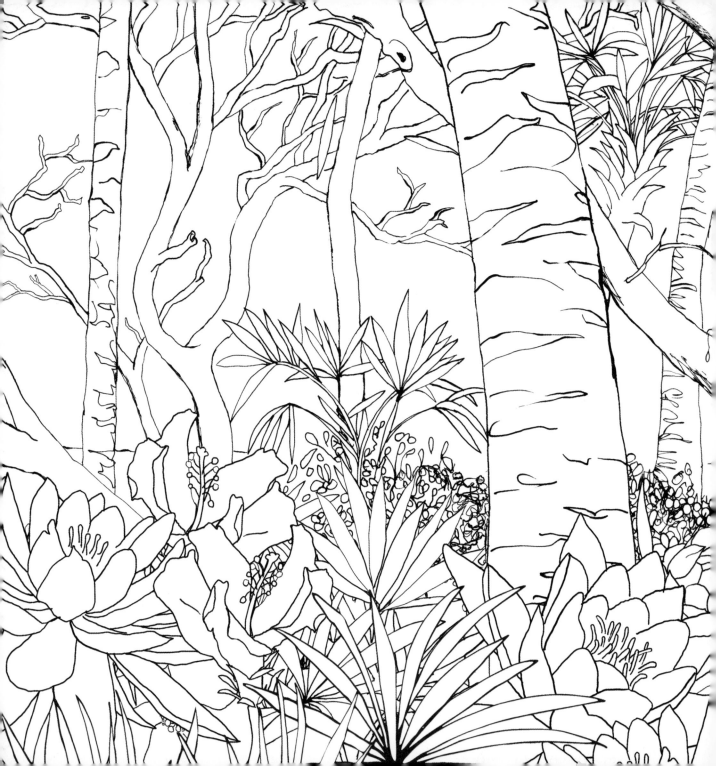

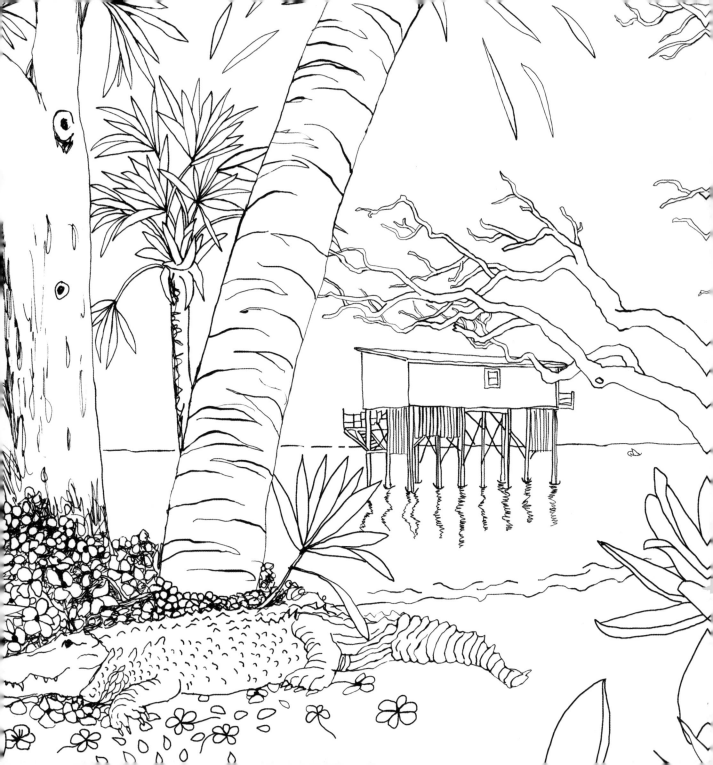

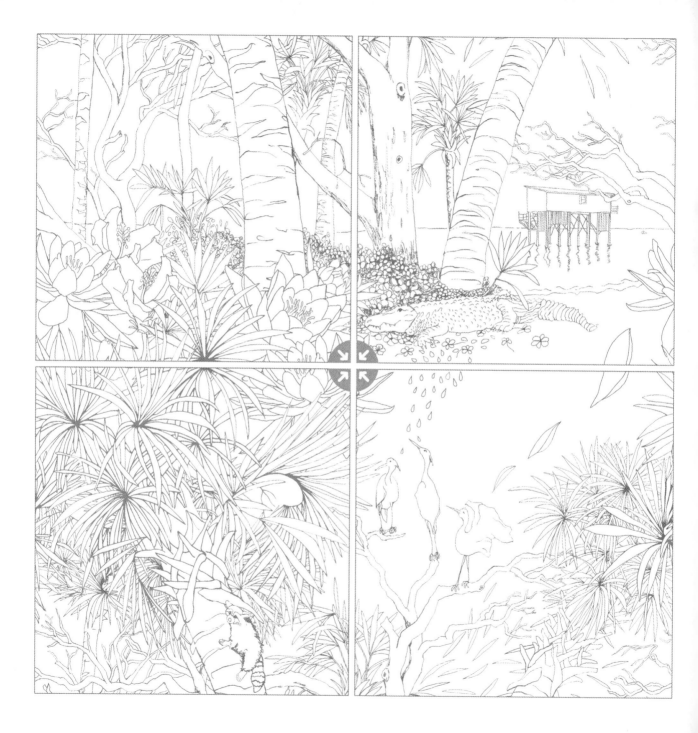

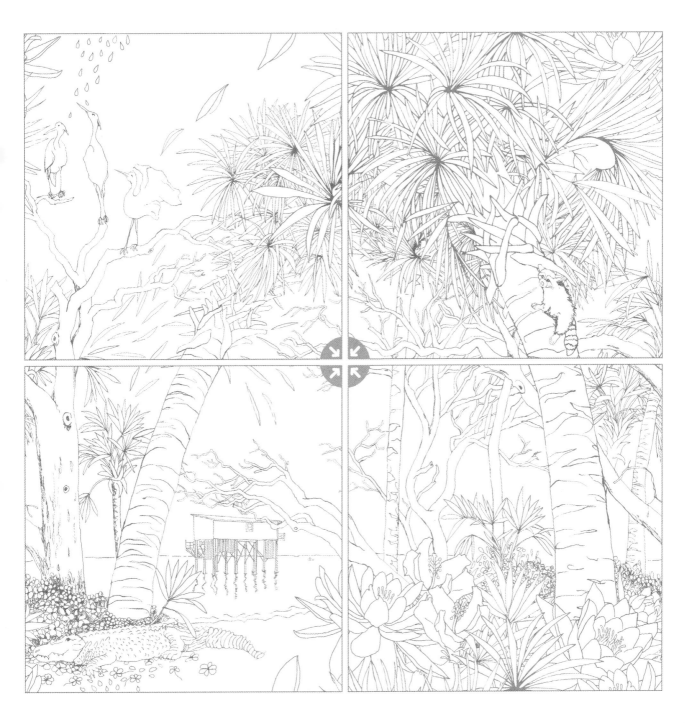

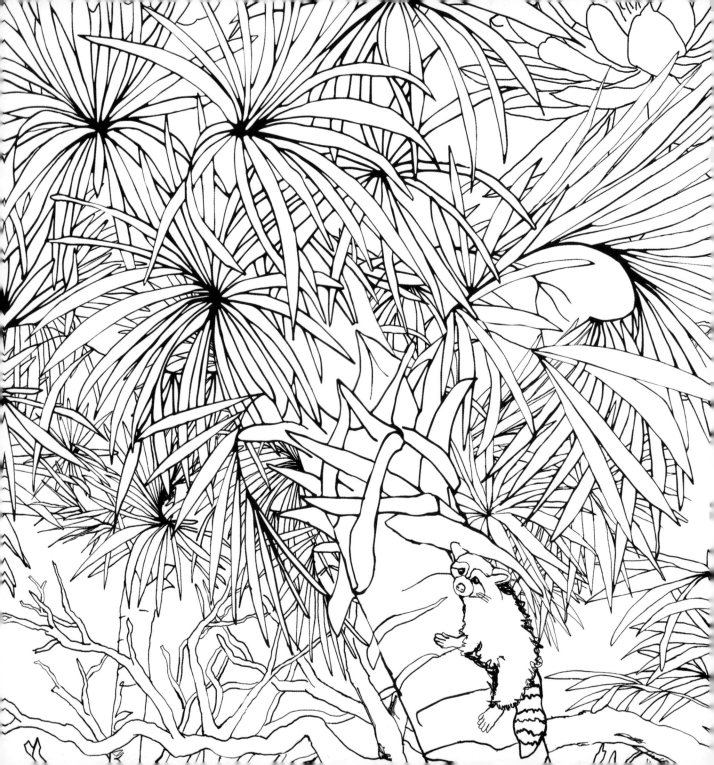

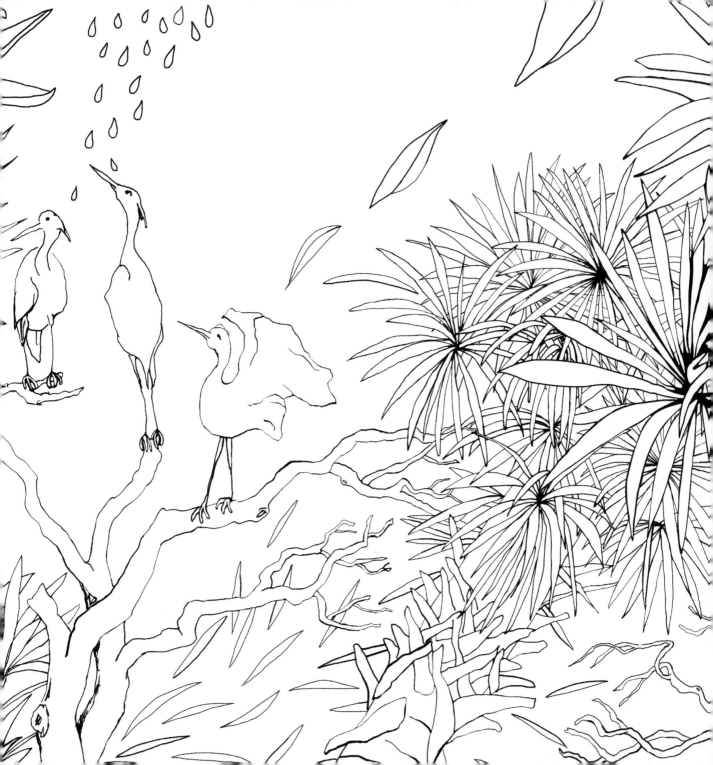

A CABIN

HUNTING ISLAND STATE PARK, SOUTH CAROLINA

A cabin once sat near sand bluffs, close to the ocean. Then the ocean arrived at the front door and gradually replaced the sand with water. For the time being, the cabin hovers in the air above the water. Humans can no longer access this place. Only the birds can peek inside the windows to see who has claimed this house as a home.

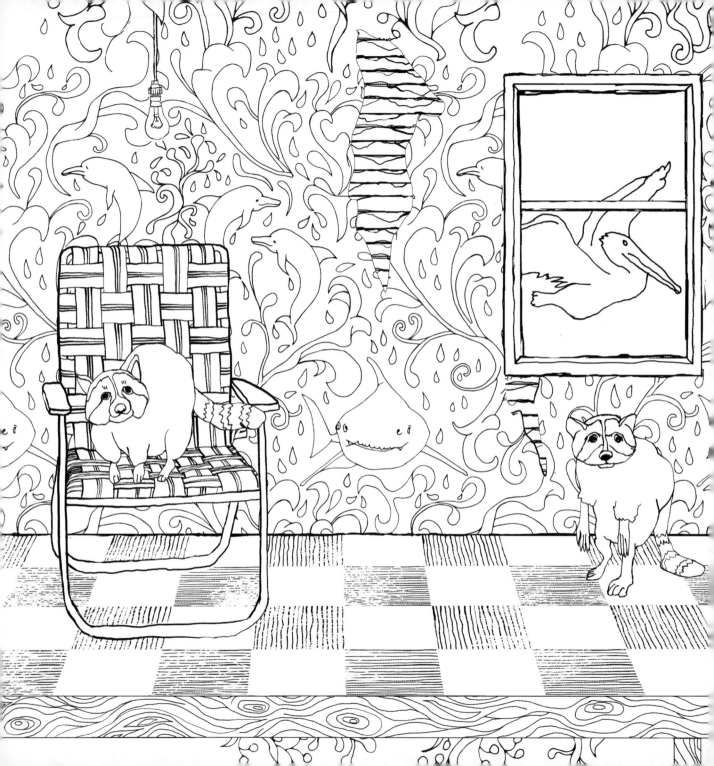

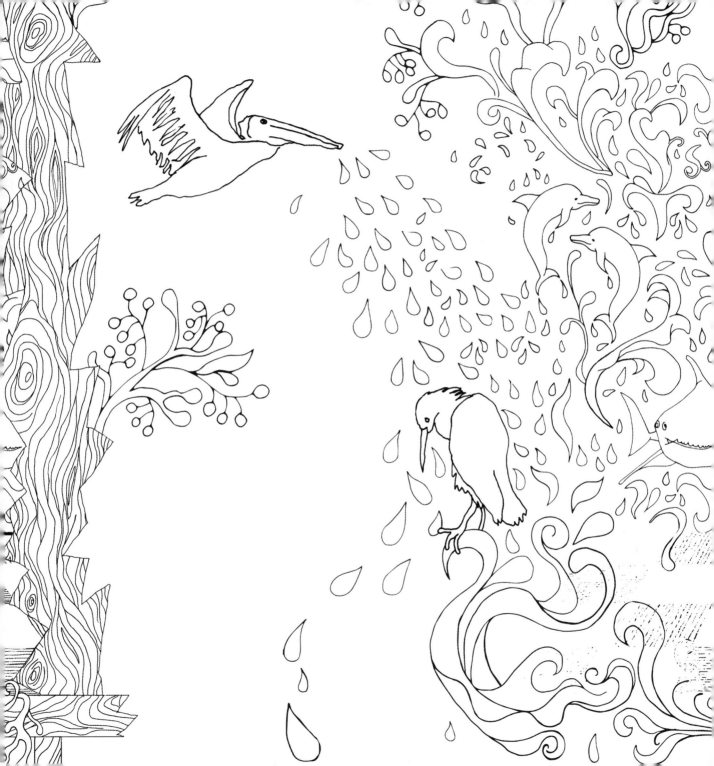

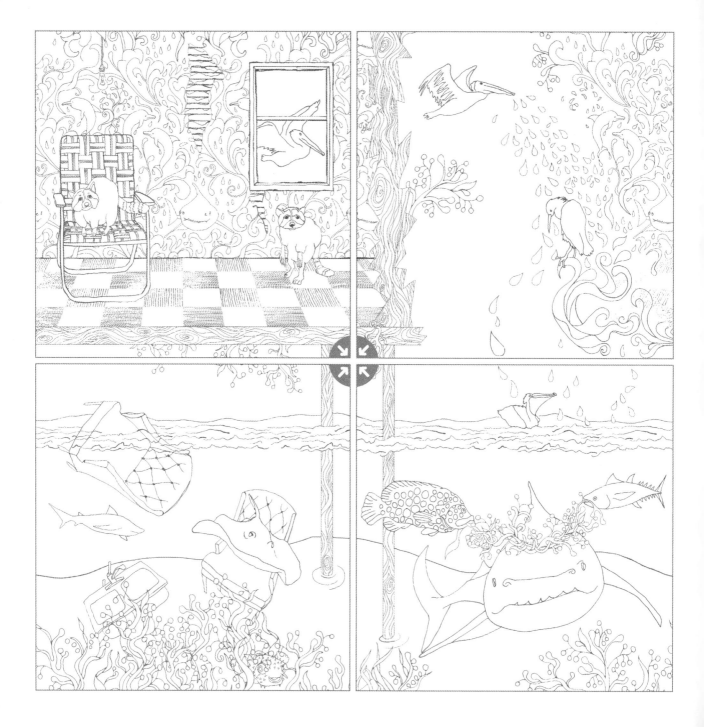

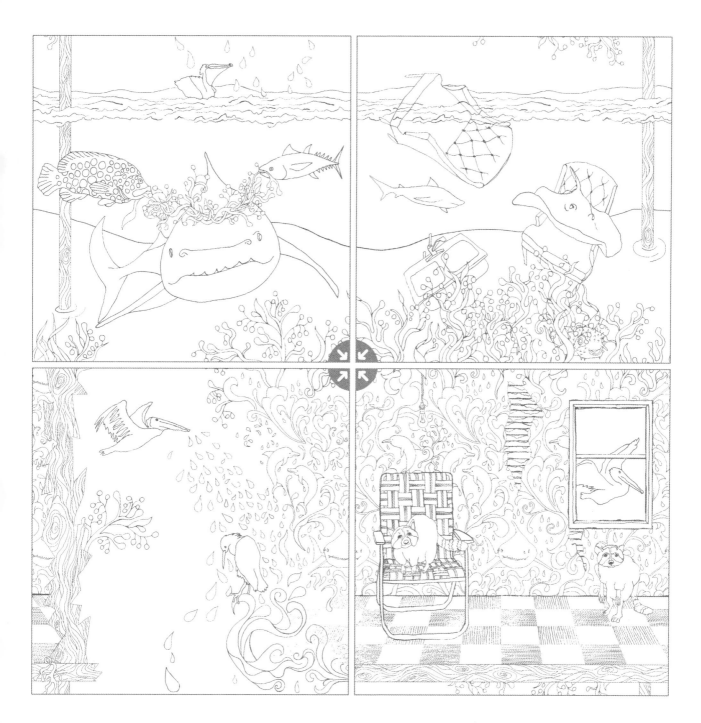

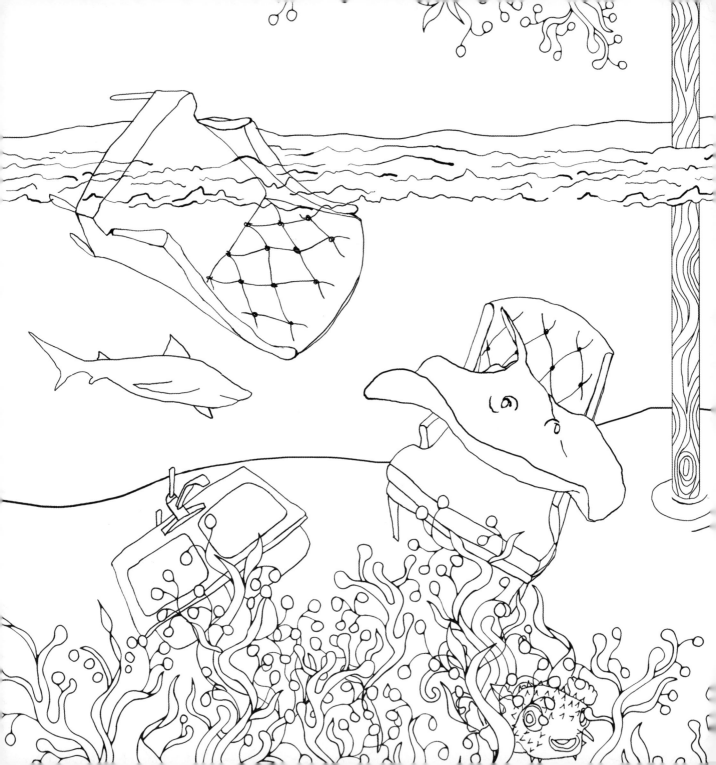

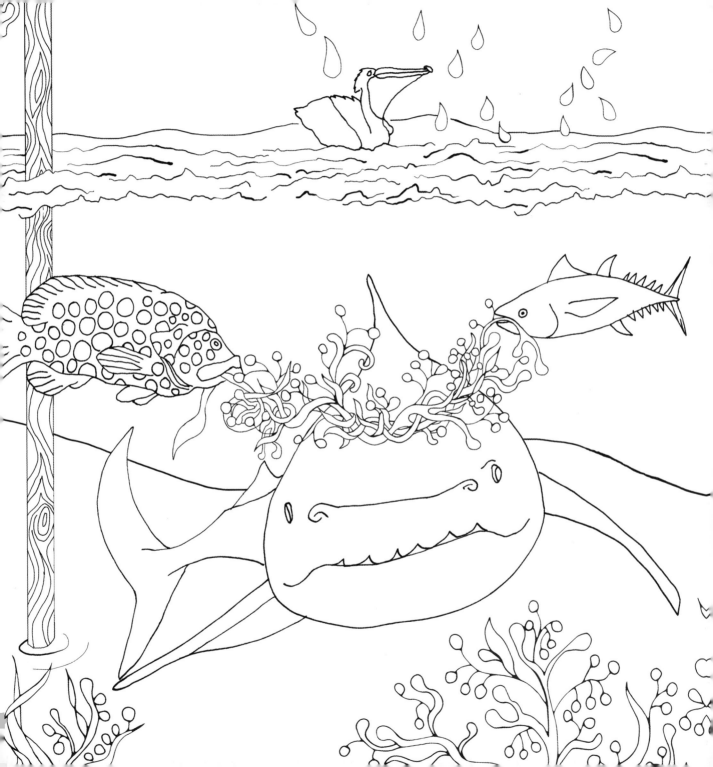

SHRIMP BOATS

ST. HELENA ISLAND, SOUTH CAROLINA

Shrimp trawlers leave early in the morning off the docks of Gay Fish Company on St. Helena Island. What will the catch be today? You never know what might show up in the nets, but one thing is for sure: sea birds and porpoises will be there to feast off of the fishermen's rejects. And locals and tourists alike will flock to Gay's to stock their coolers with fresh shrimp.

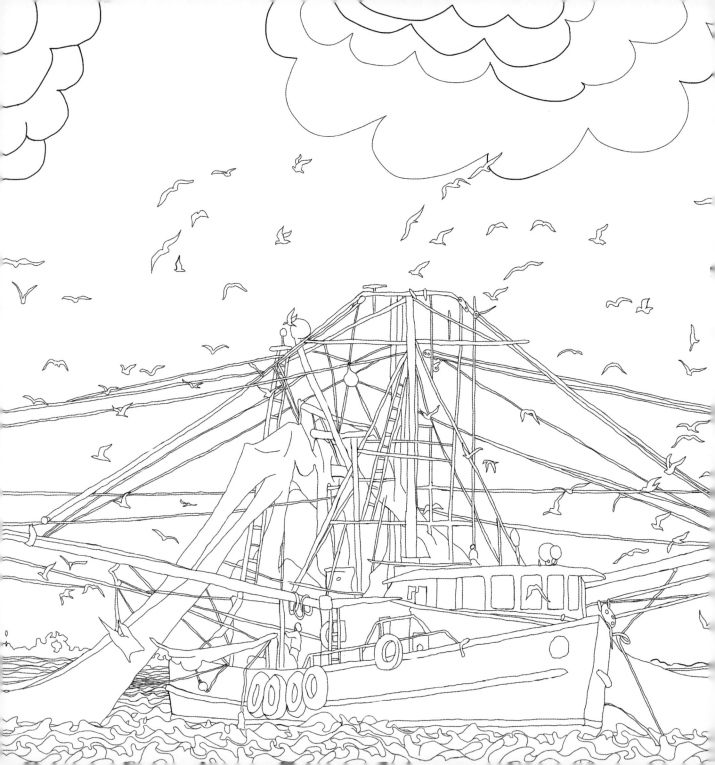

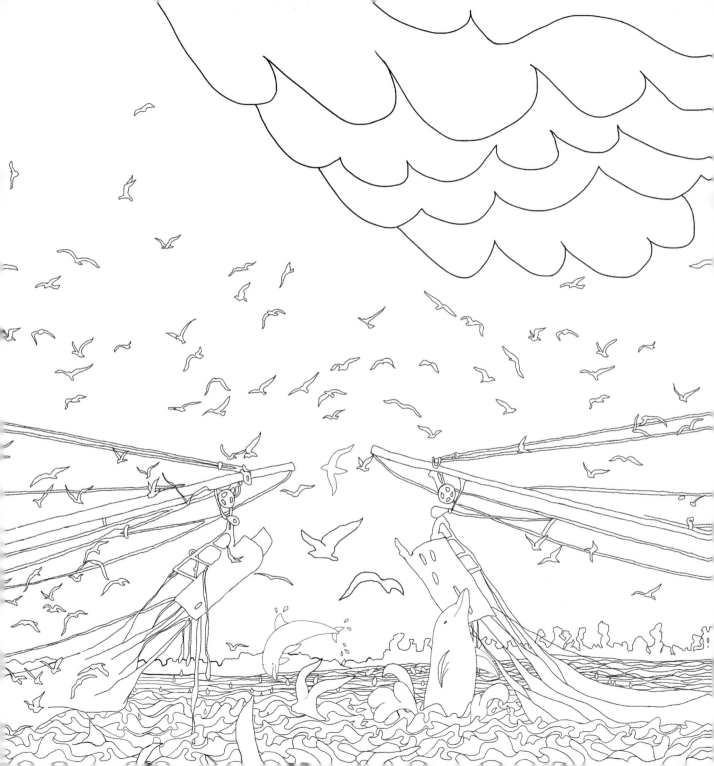

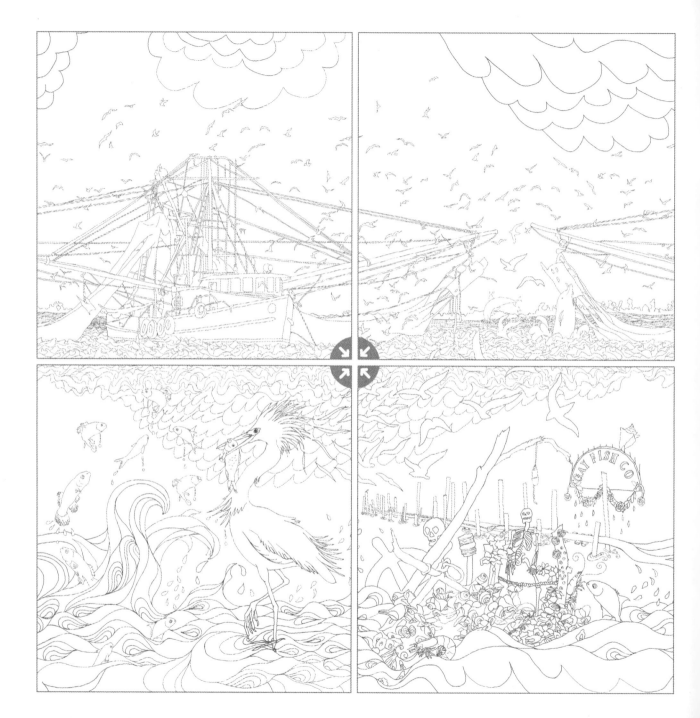

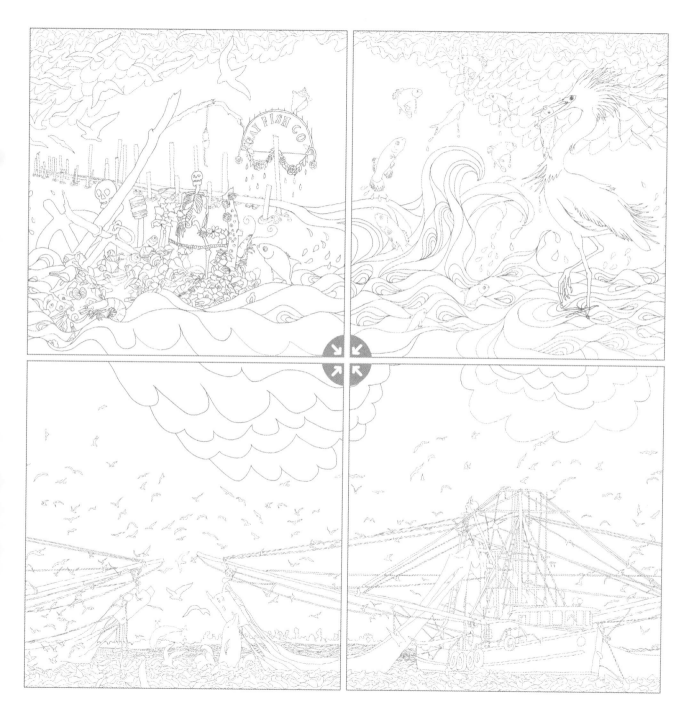

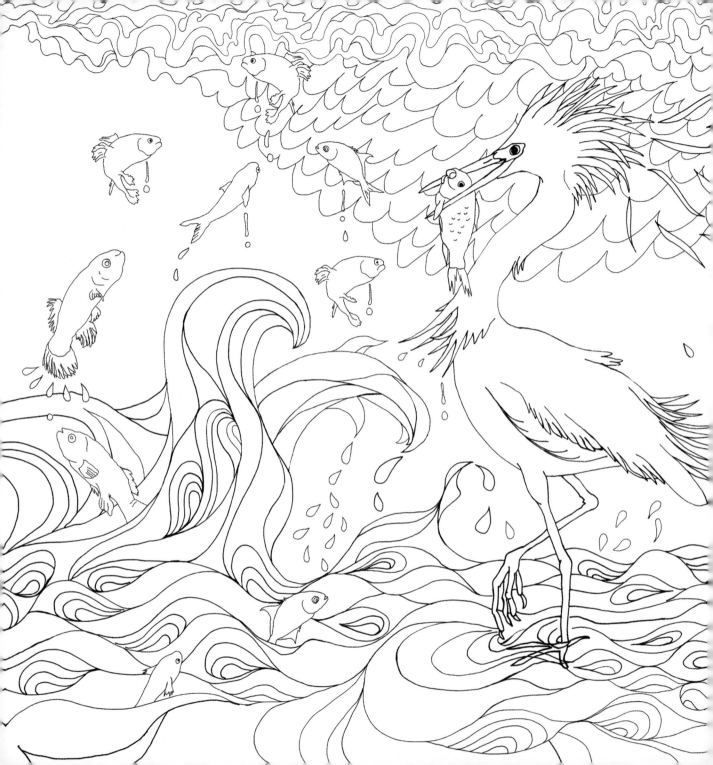

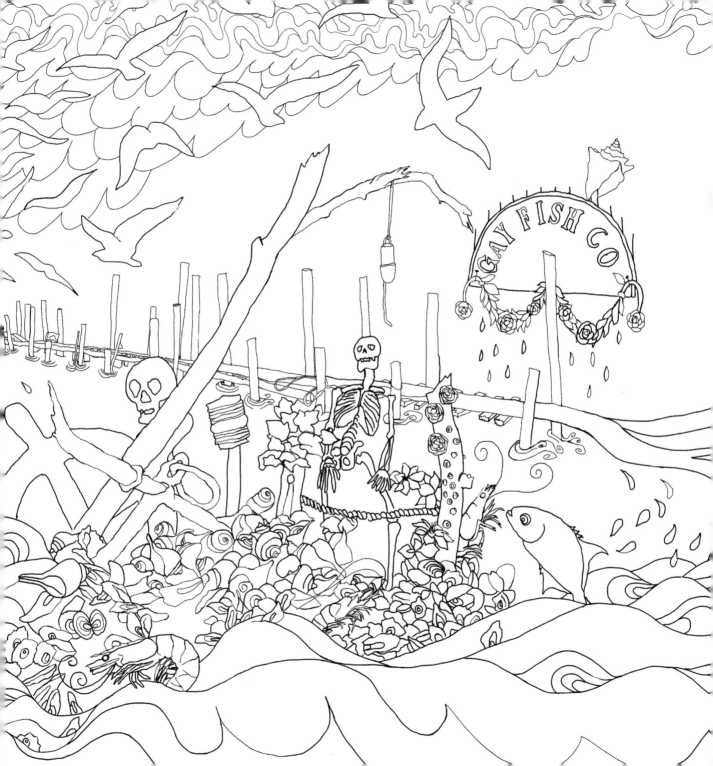

Marsh

SEA ISLANDS

The marshes of the Lowcountry are home to snakes, fiddler crabs, marsh flowers, and an infinite number of dragonflies that fly from one stiff reed to the next. Watch the alligators and diamondback terrapins come and go in search of a large lagoon, rich with deliciously brackish water.

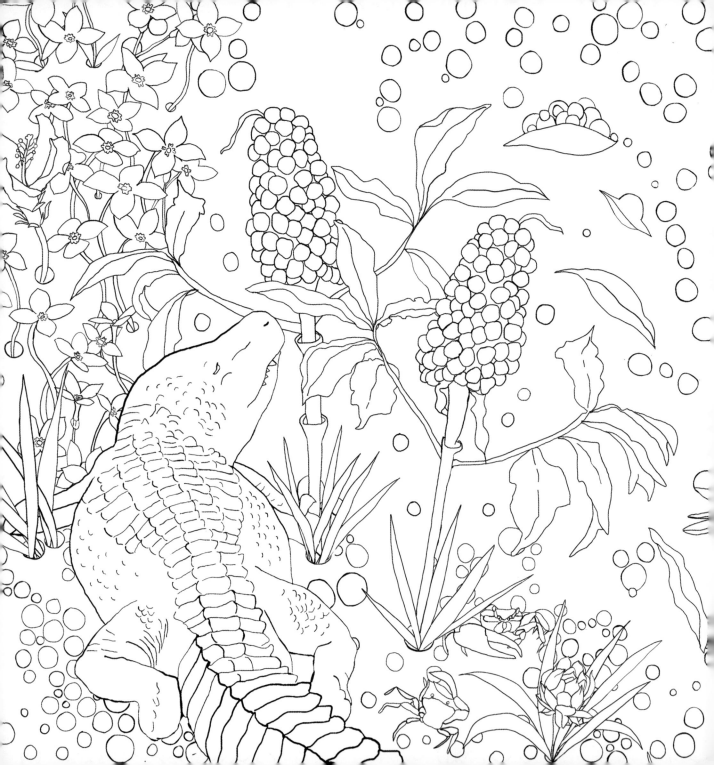

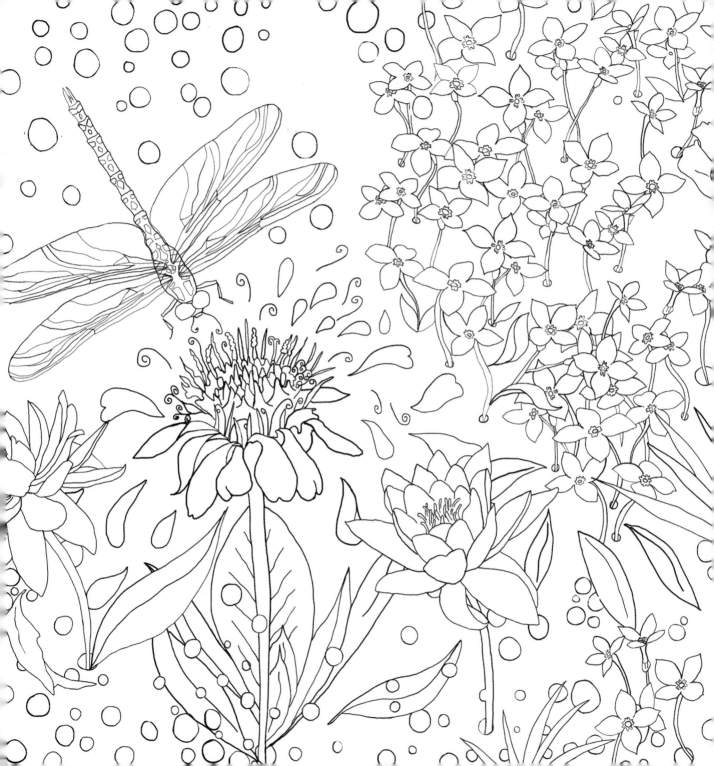

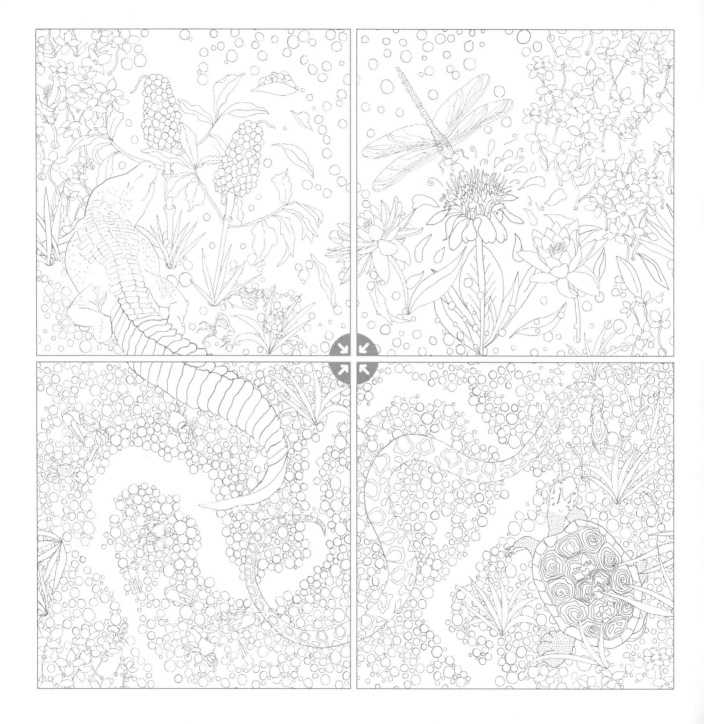

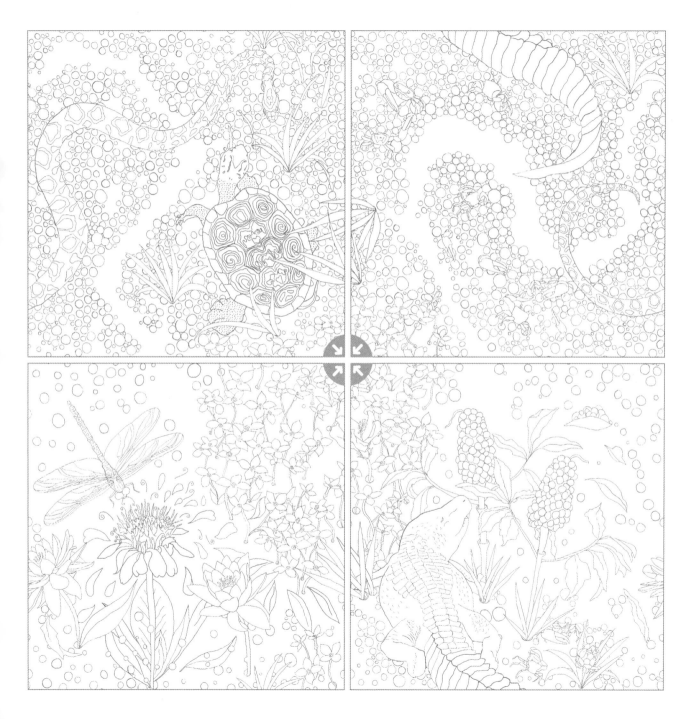

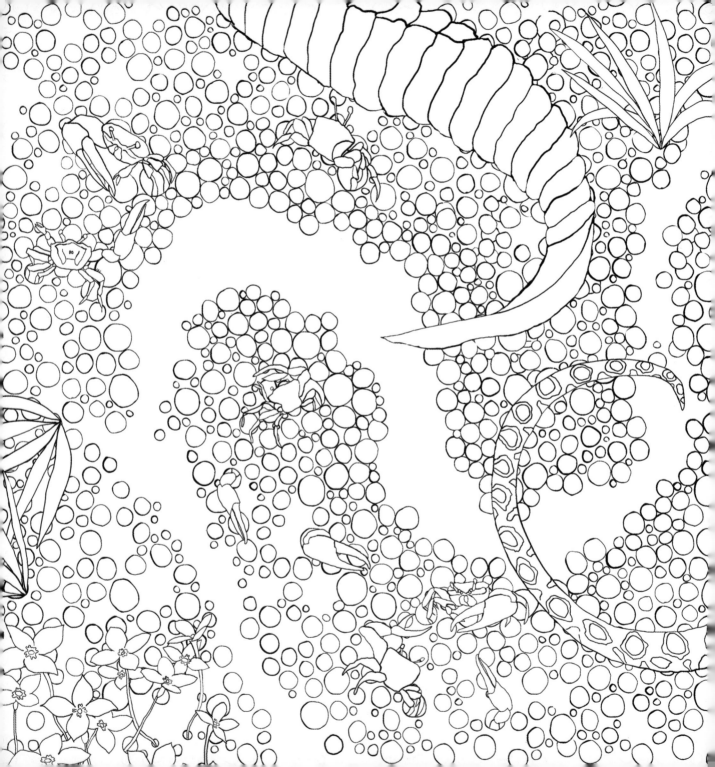

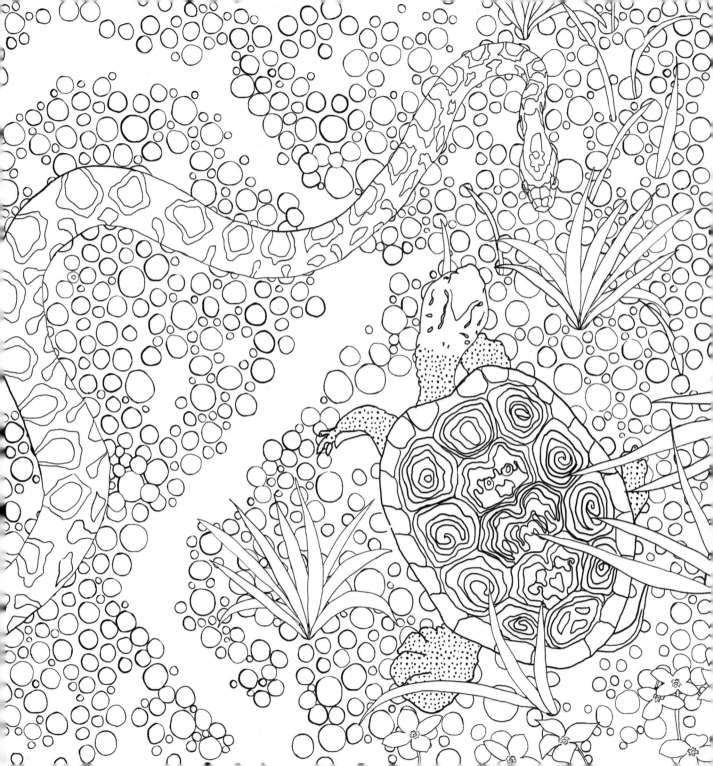

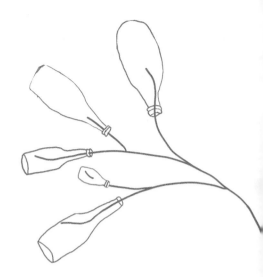

PENN CENTER

ST. HELENA ISLAND, SOUTH CAROLINA

Tucked away on Dr. Martin Luther King Jr. Drive, nestled in a canopy of live oaks and Spanish moss, sits the campus of Penn Center. Across the street is Brick Baptist Church, where freed slaves were once taught and where Martin Luther King Jr. practiced his "I Have a Dream" speech. Since the 1970s, Penn Center has worked to keep the surrounding land of St. Helena Island in Gullah hands. Drive around the area and you are likely to see some "haint blue" homes, painted this precise shade to keep out the haints, since it's known by the Gullah that these spirits won't cross water.

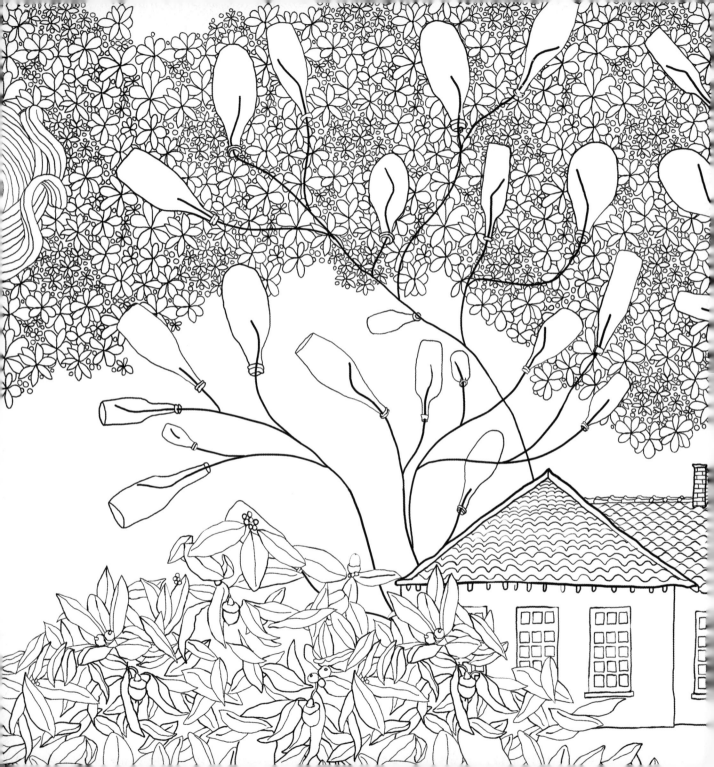

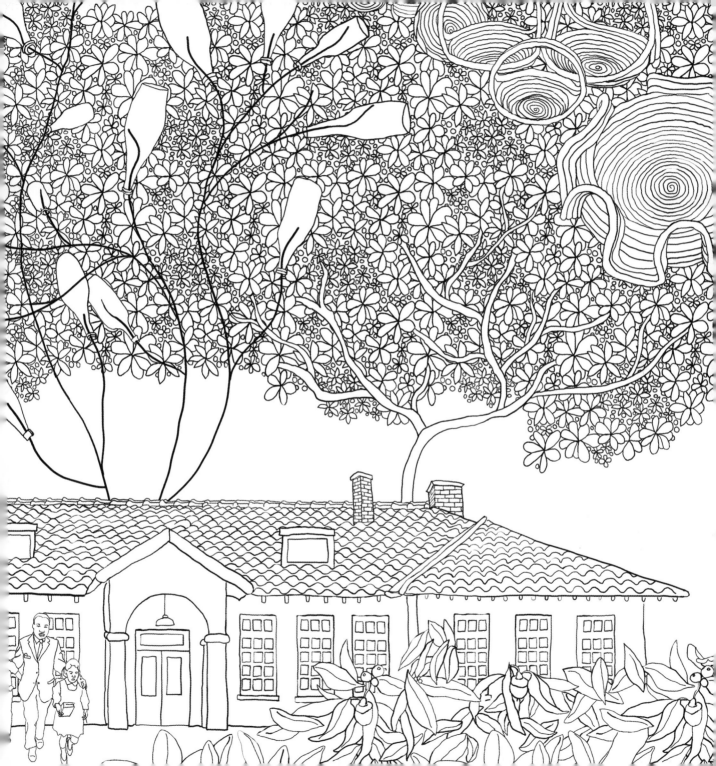

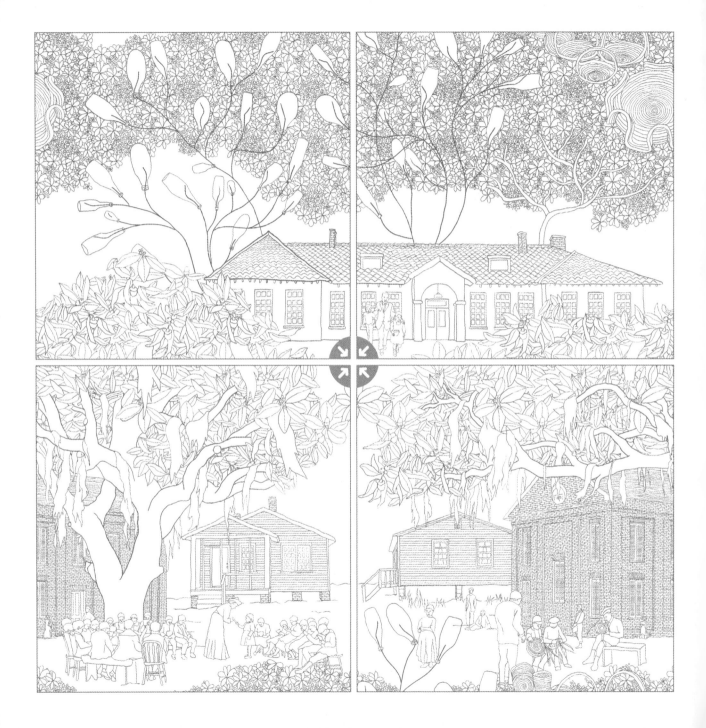

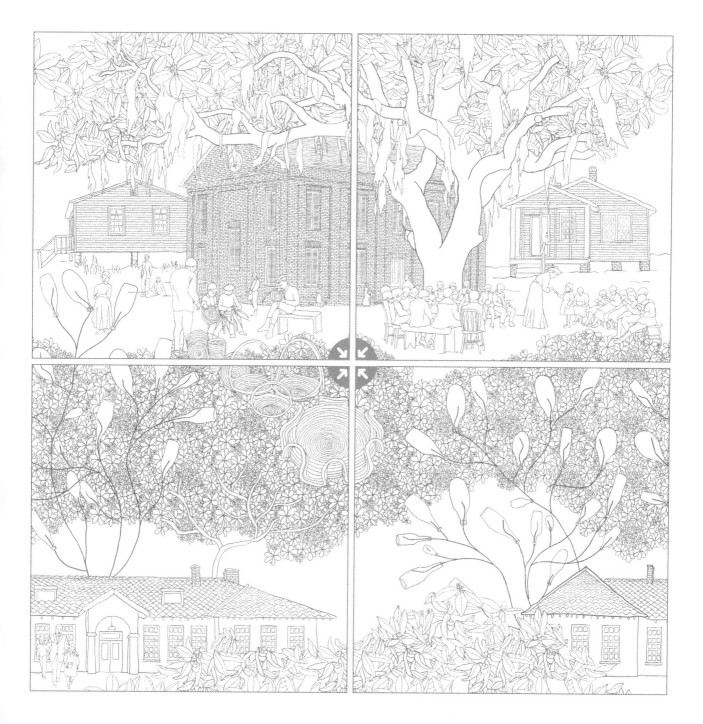

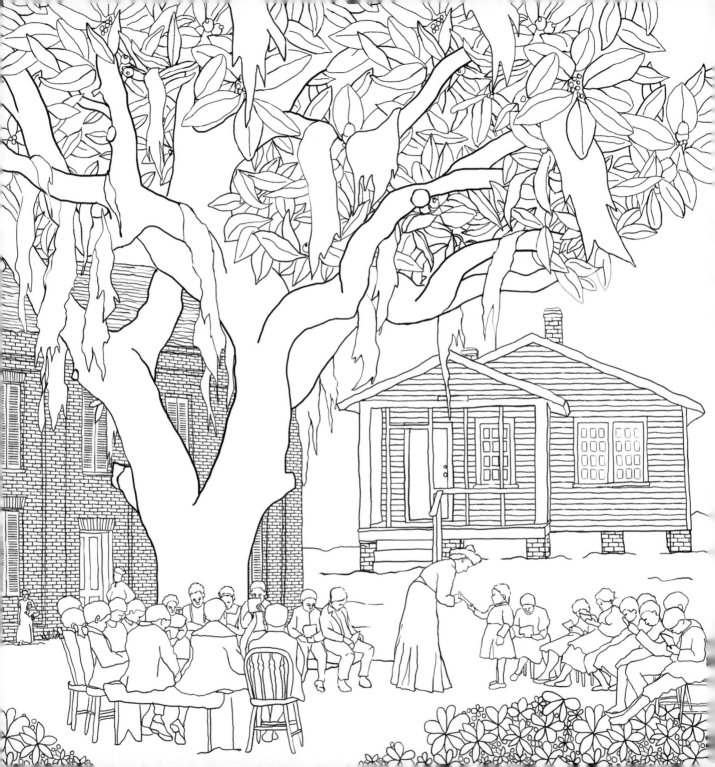

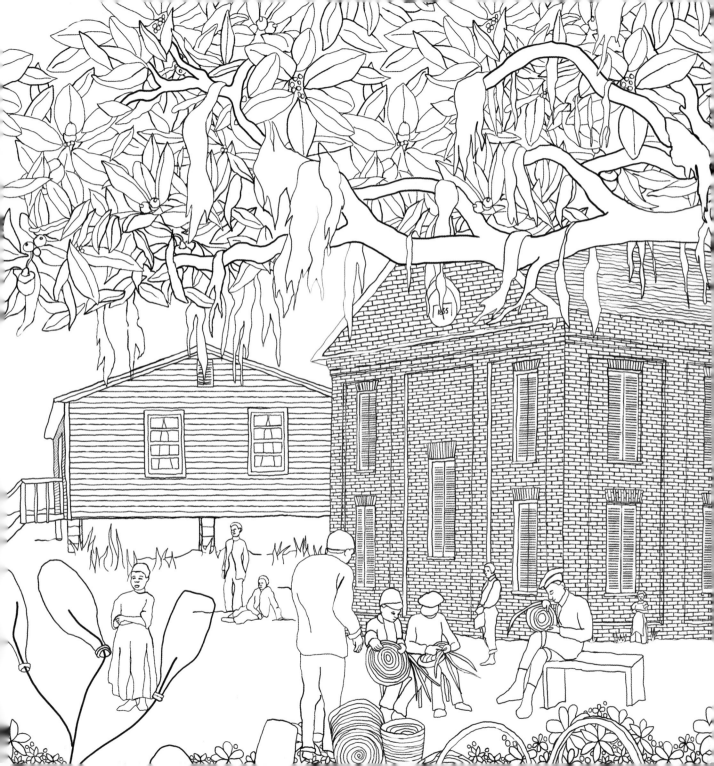

BONAVENTURE CEMETERY

SAVANNAH, GEORGIA

Located on the site of a former plantation, the quaint and quiet Gothic beauty of Bonaventure Cemetery has been celebrated by artists in poetry and literature for more than a century. There is certainly something about the place that can be felt, but not always seen. Study the gestures in the statues. Follow the sound of the crows cawing. Listen to wind as it travels from the Wilmington River through Spanish moss and holly bushes.

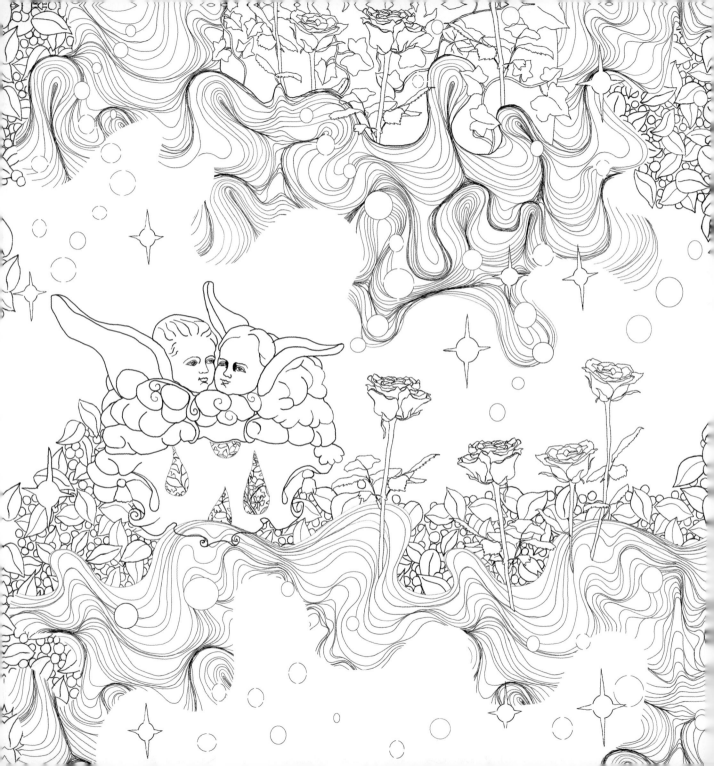

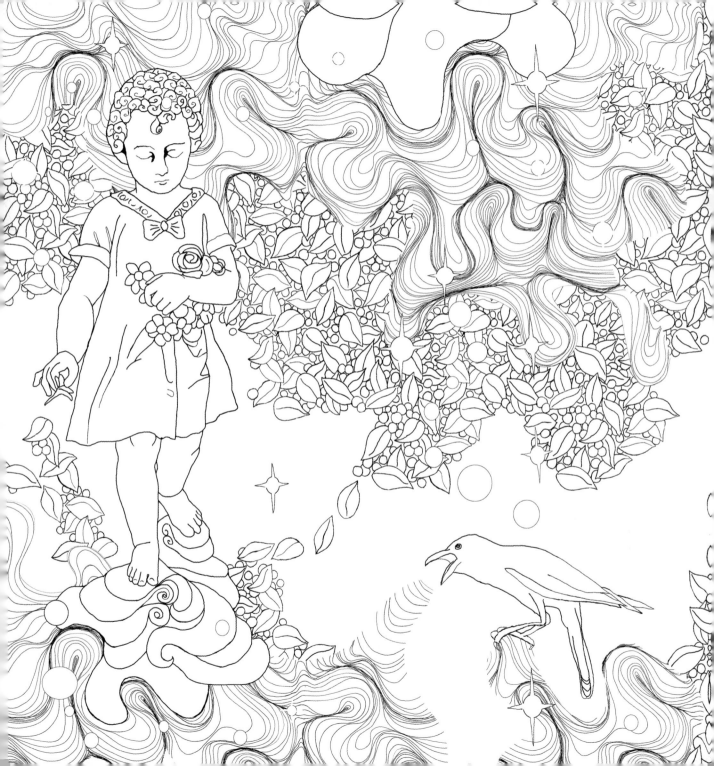

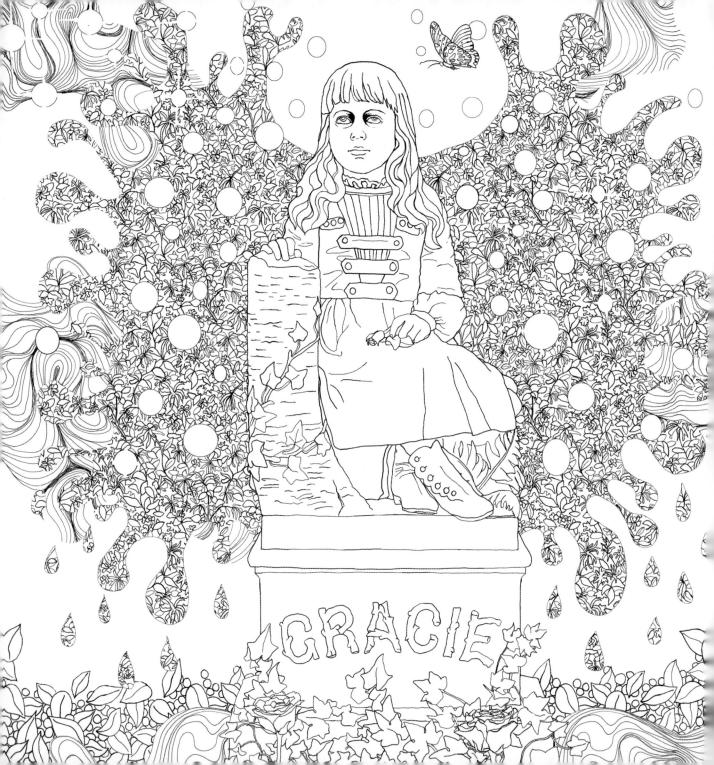

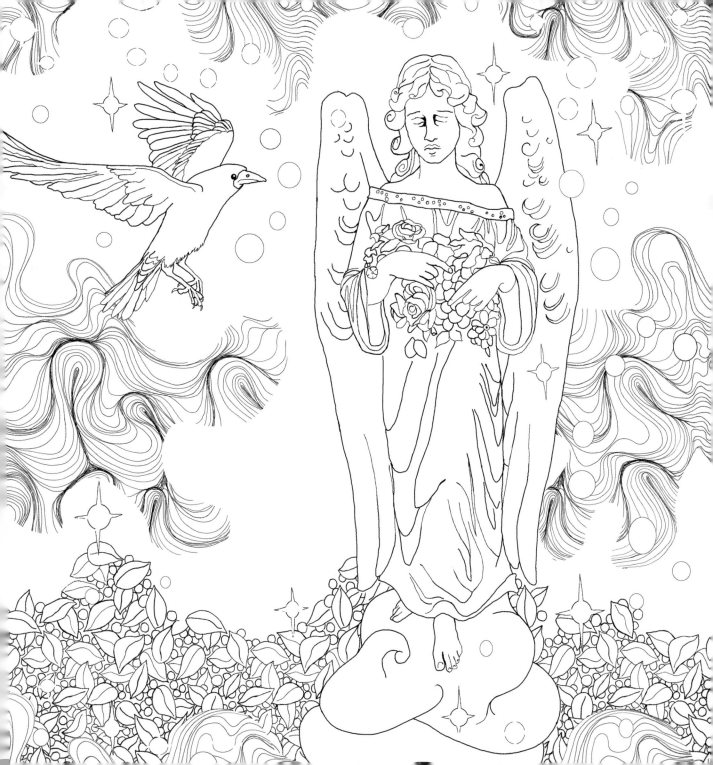

RIVER STREET

SAVANNAH, GEORGIA

In 1887, nineteen-year-old Florence Martus began waving to the ships that sailed into the Savannah River and she continued to do so every day for the next forty-four years, earning her the name "the Waving Girl of Savannah." Today, a bronze sculpture of Florence continues to greet ships as they glide by on their way to the Port of Savannah. A wall of reclaimed cotton warehouses line River Street behind the *Waving Girl*, their facades worn down by wind and rain, as layered and organic as a pier encrusted with barnacles and oyster shells.

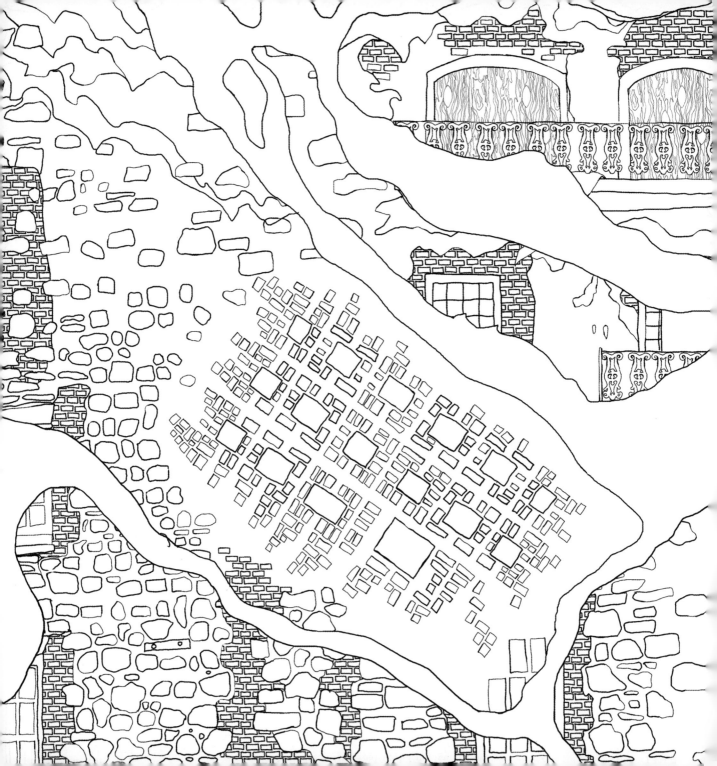

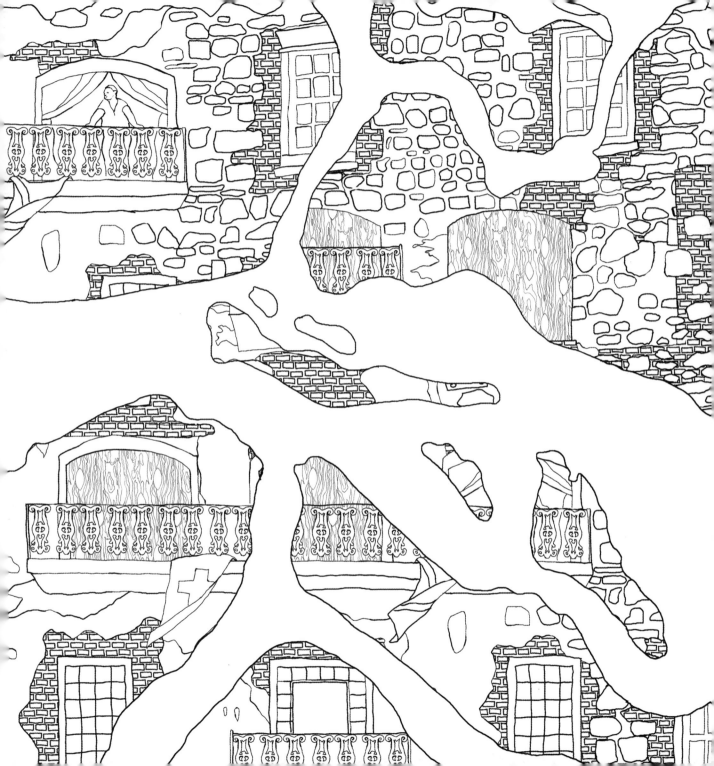

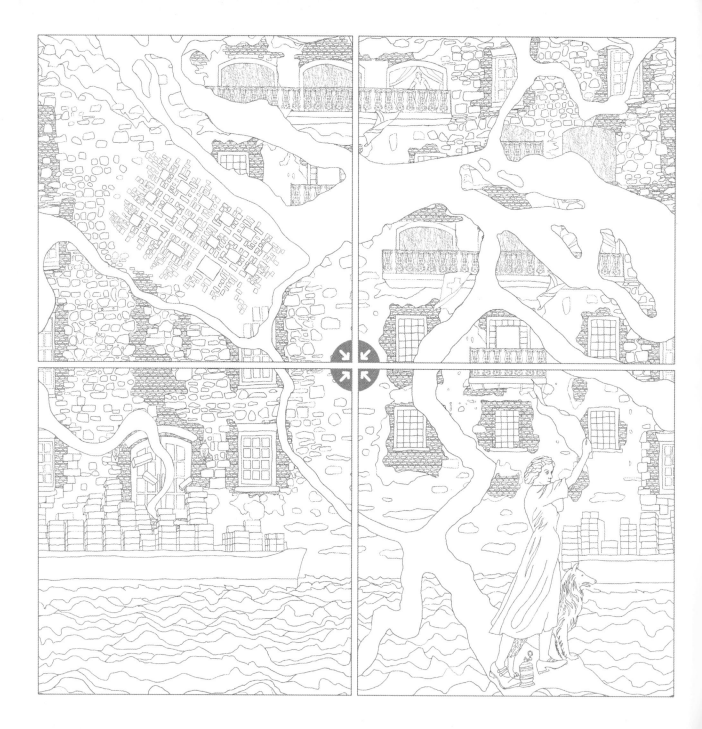

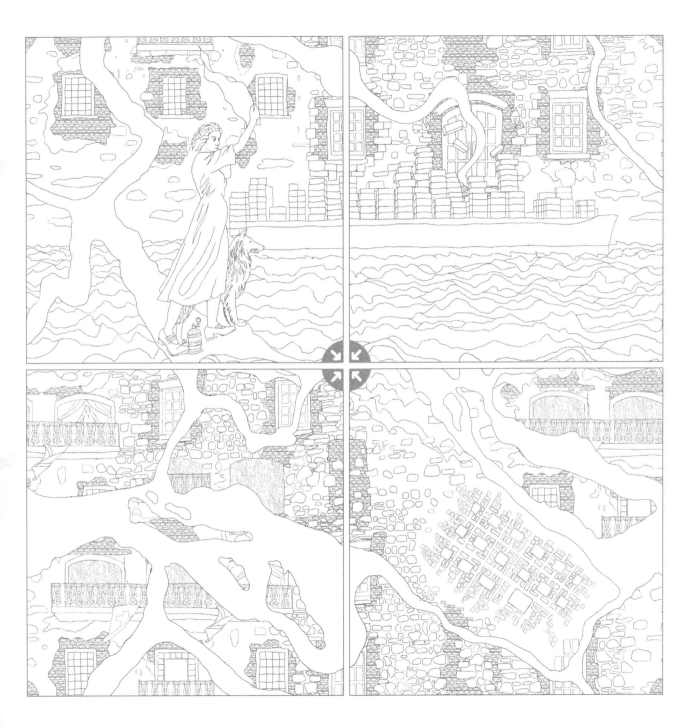

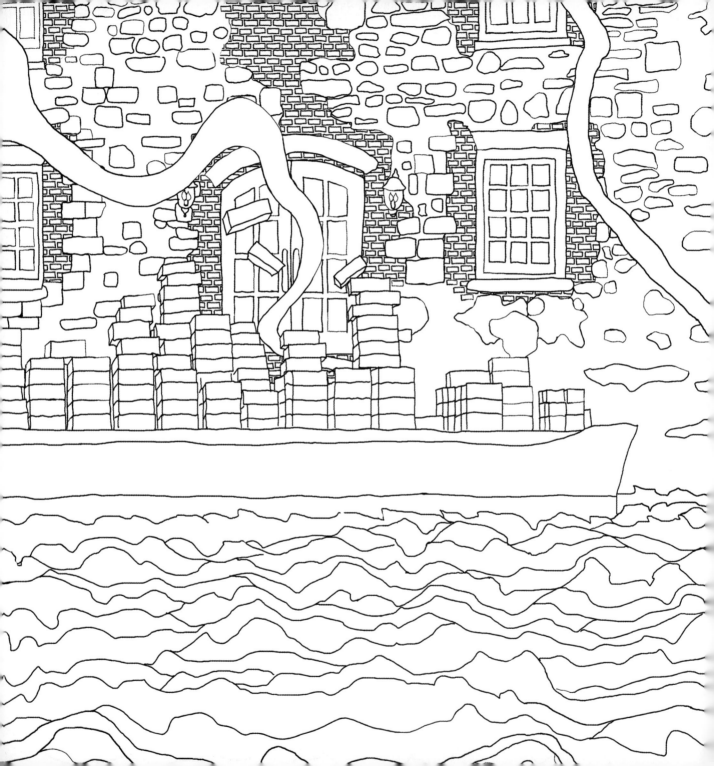

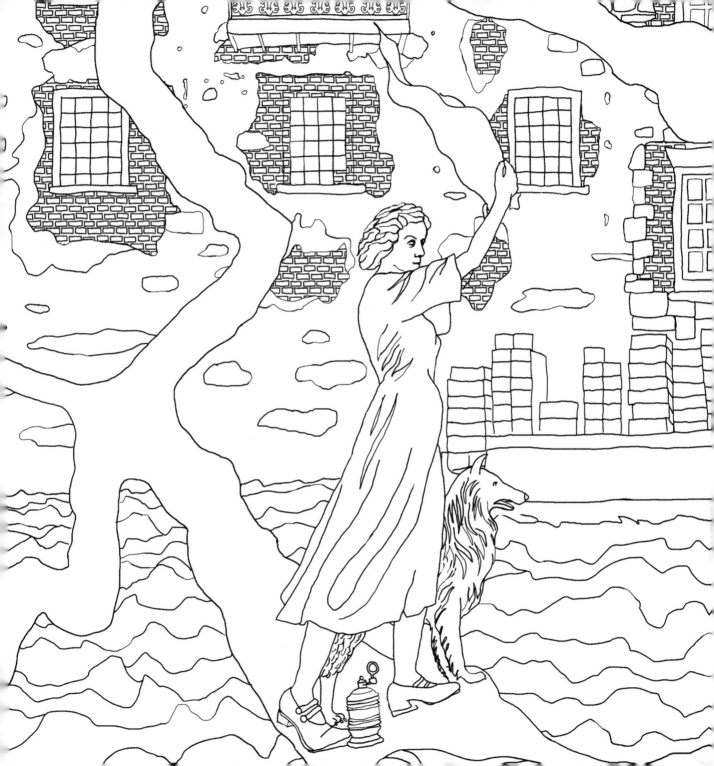

PRIVATE GARDEN

CHARLESTON, SOUTH CAROLINA

Open the wrought iron gates. Step inside the brick courtyards of old homes and you will find the private gardens of Charleston. Sculptures and fountains stand guard over the well-kept beds, but be on the lookout for the unexpected.

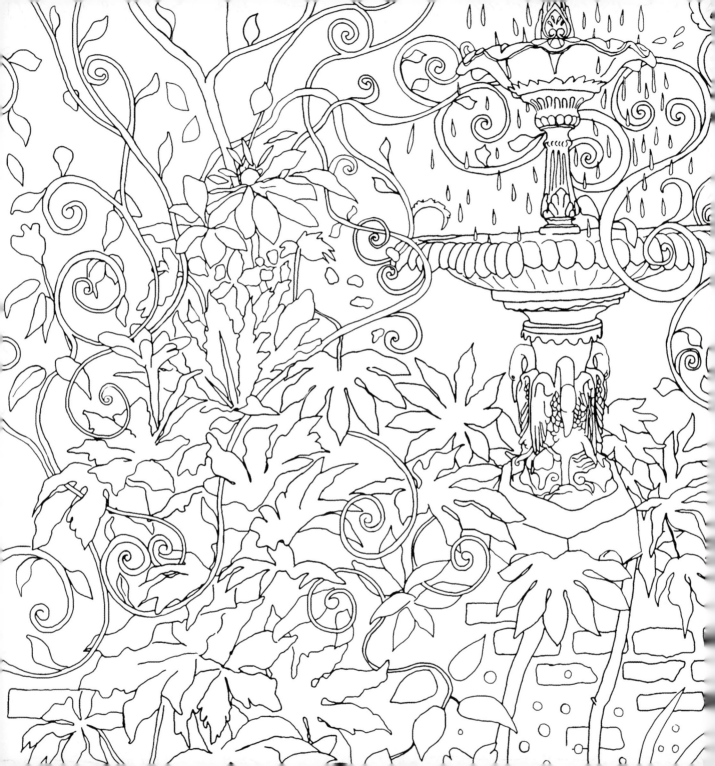

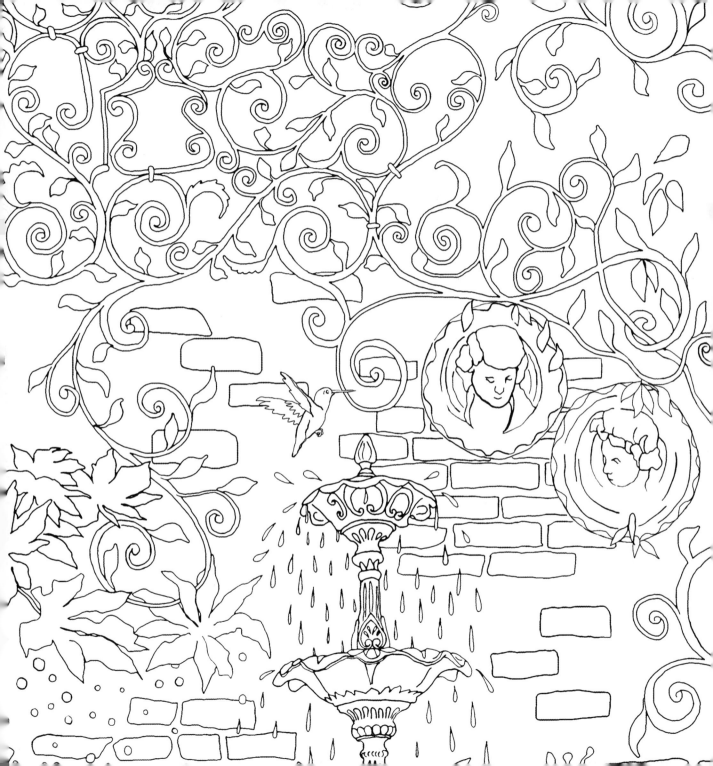

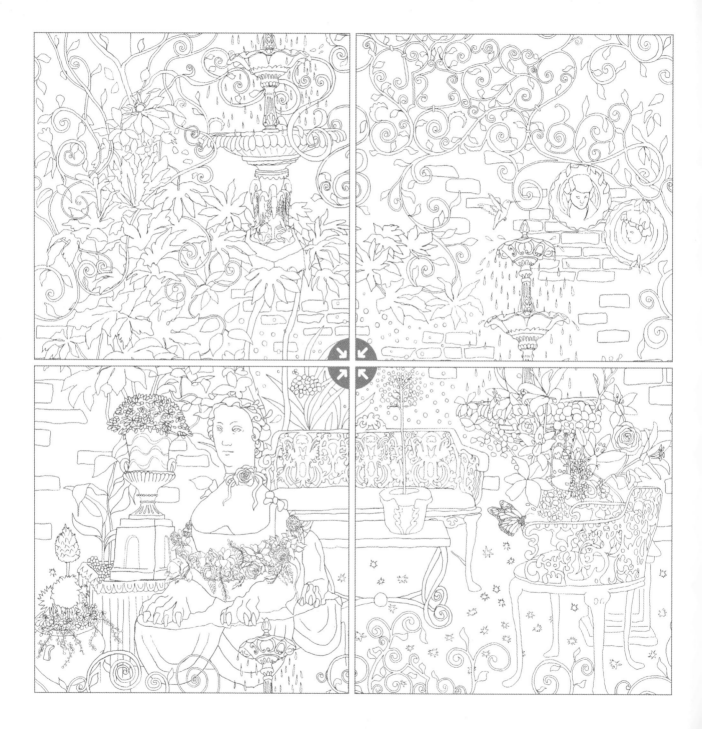

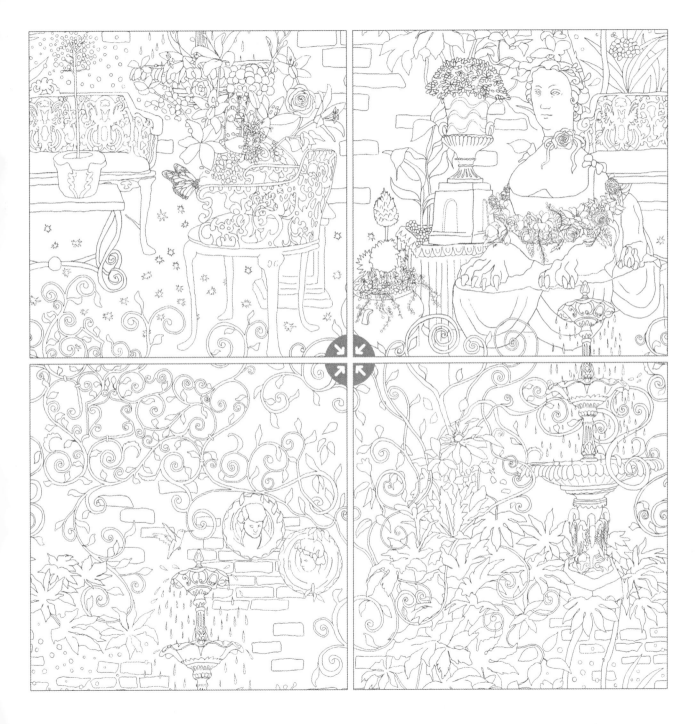

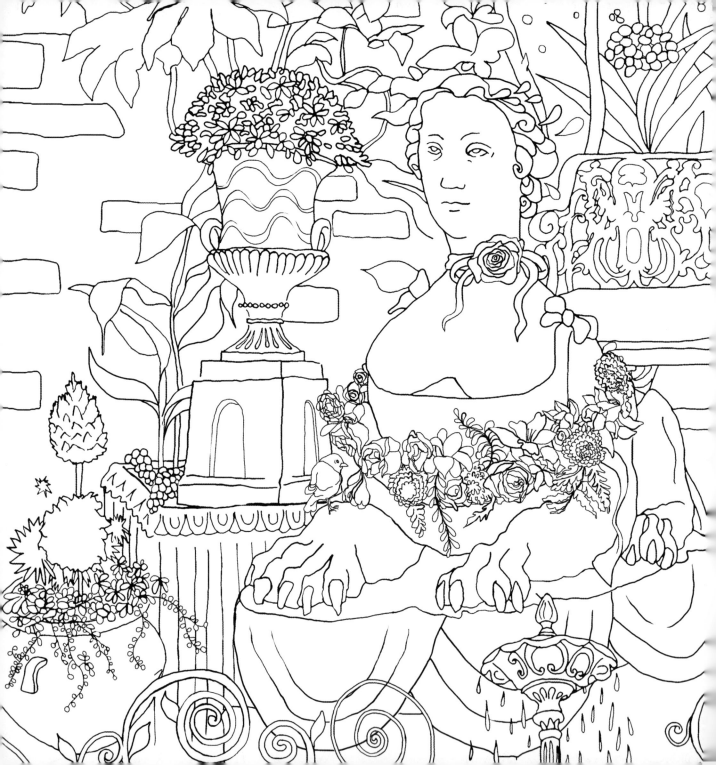

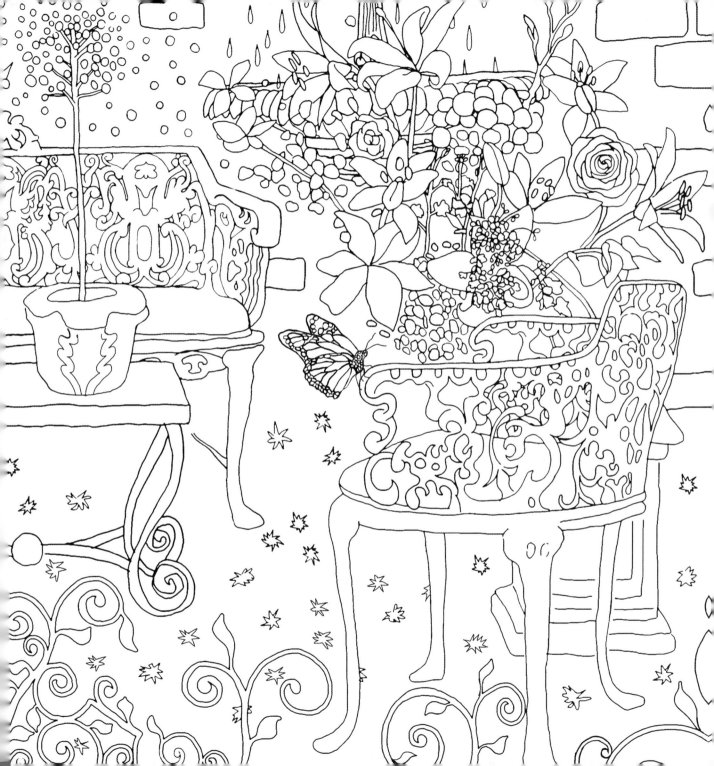

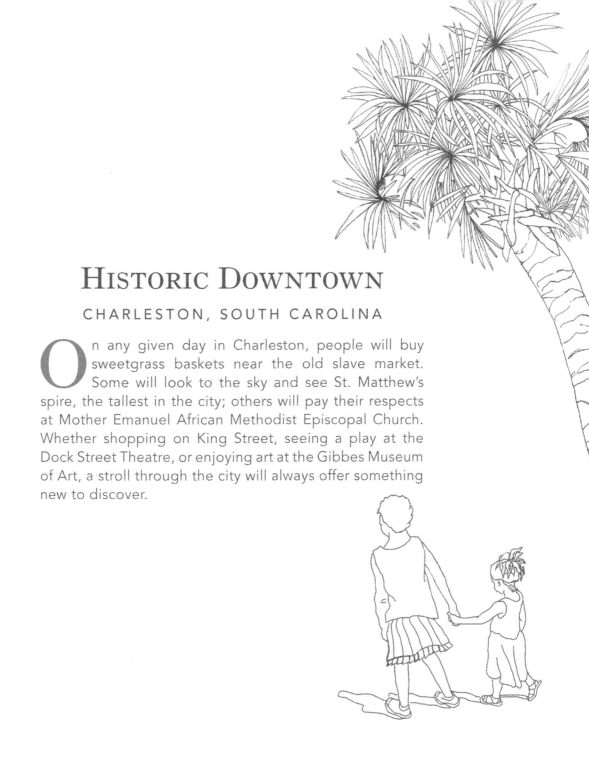

HISTORIC DOWNTOWN

CHARLESTON, SOUTH CAROLINA

On any given day in Charleston, people will buy sweetgrass baskets near the old slave market. Some will look to the sky and see St. Matthew's spire, the tallest in the city; others will pay their respects at Mother Emanuel African Methodist Episcopal Church. Whether shopping on King Street, seeing a play at the Dock Street Theatre, or enjoying art at the Gibbes Museum of Art, a stroll through the city will always offer something new to discover.

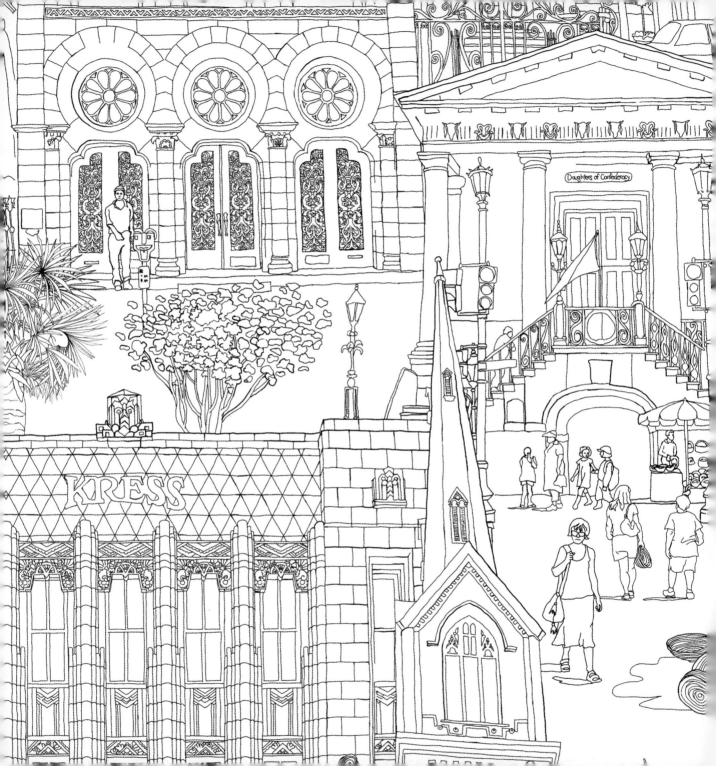

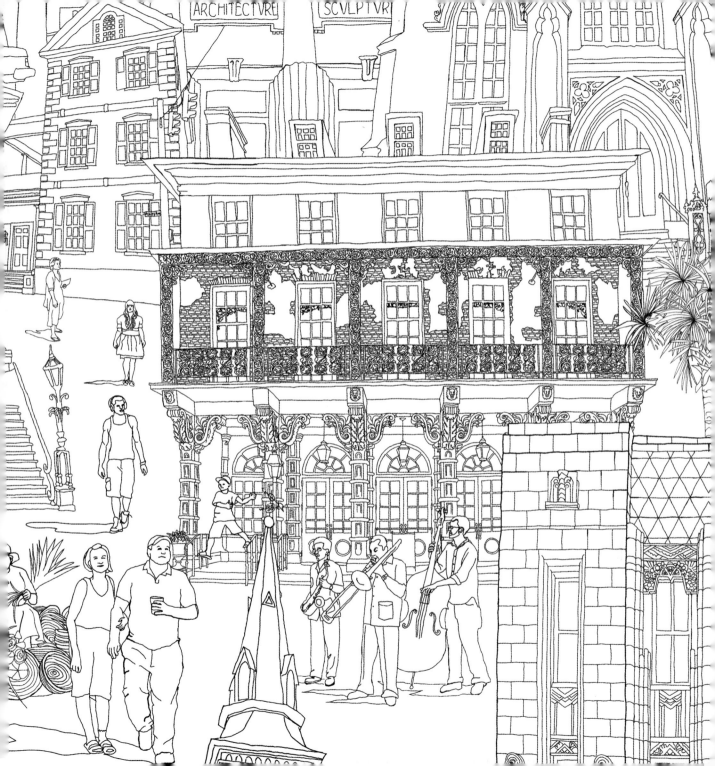

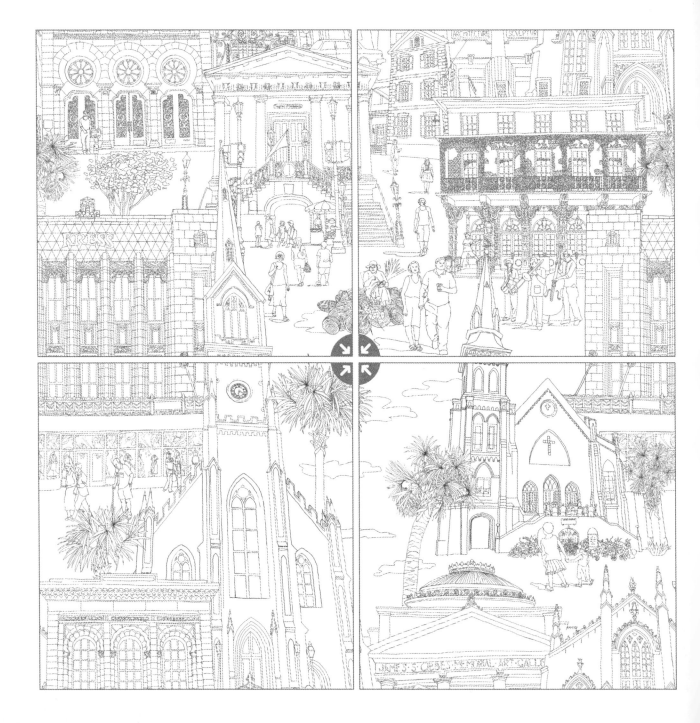

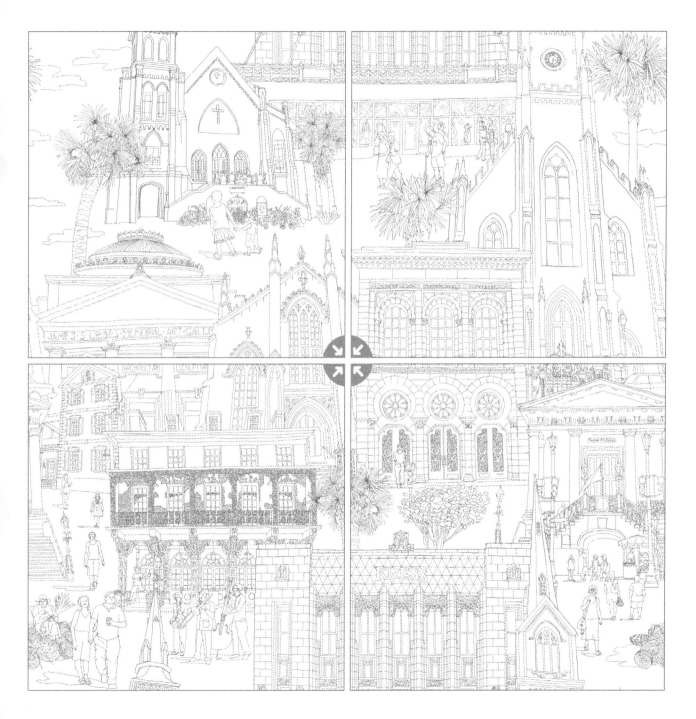

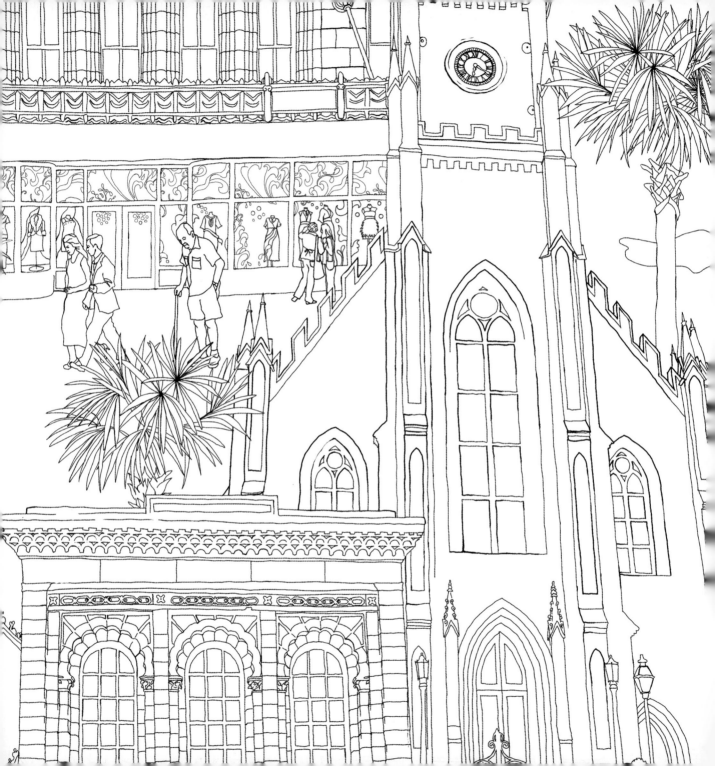

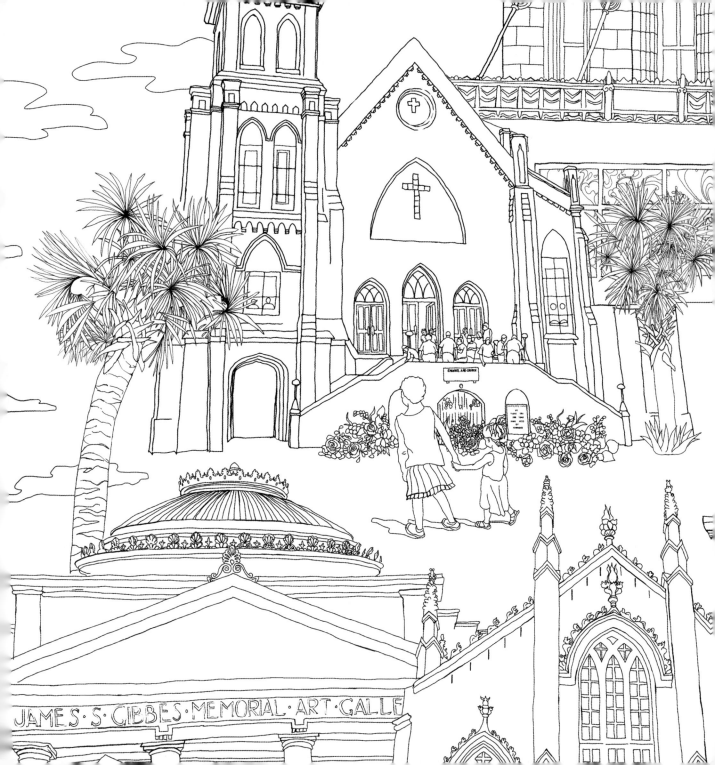

LOWCOUNTRY RUINS

SOUTH CAROLINA

Throughout the Lowcountry are once-glorious buildings in an arrested state of decay. Old Sheldon Church, near Yemassee, was originally burnt by the British in 1779 and later stripped from the inside by locals looking for raw material to rebuild their destroyed homes after the Civil War. On Lands End Road in St. Helena, the tabby ruins of the Chapel of Ease almost glow. A large abandoned beach house on Pritchards Island hovers above the beach on multiple pilings and is accessible only by boat. But you won't be able to get there on the *Tiderunner*. The boat used in the filming of *The Prince of Tides* sits in the marsh near Gay Fish Company, ravaged by the sun and saltwater.

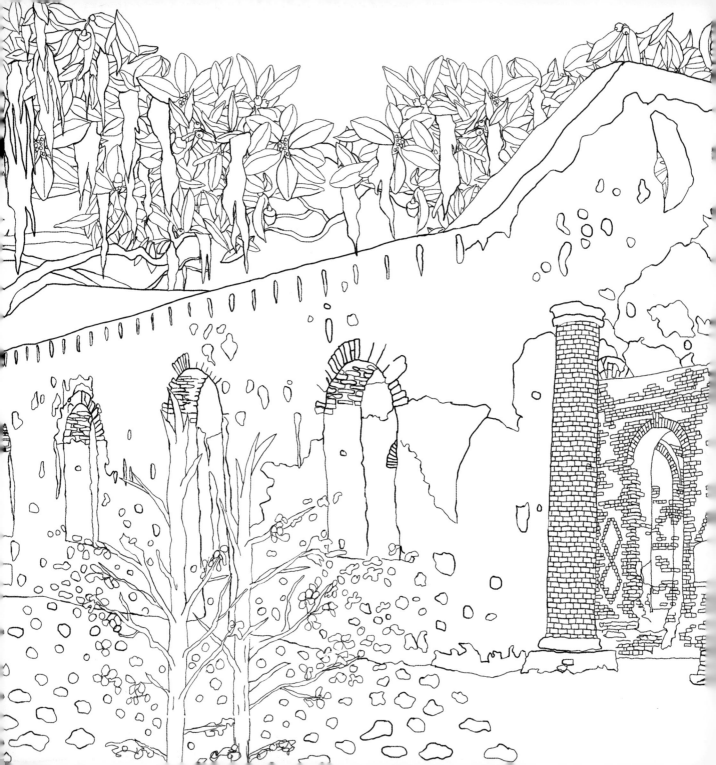

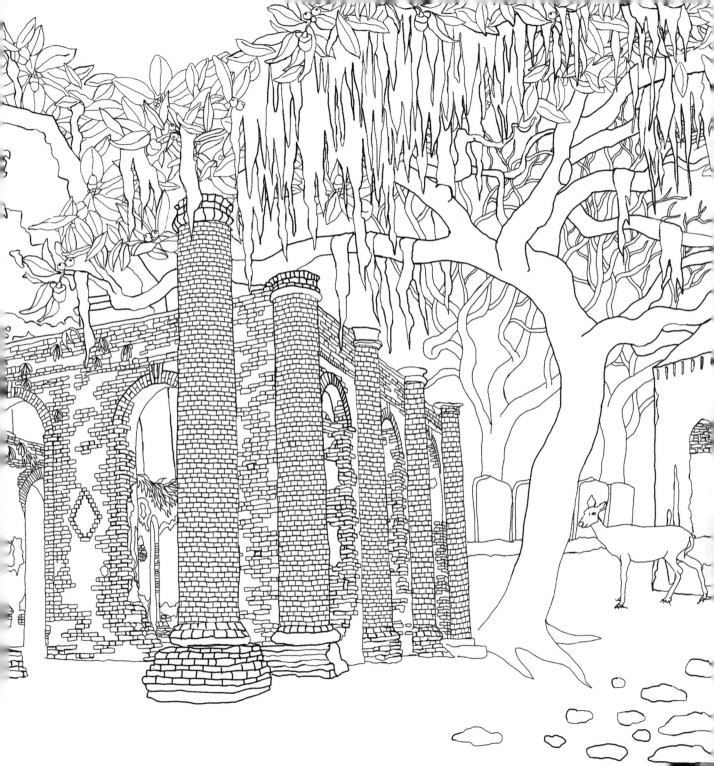

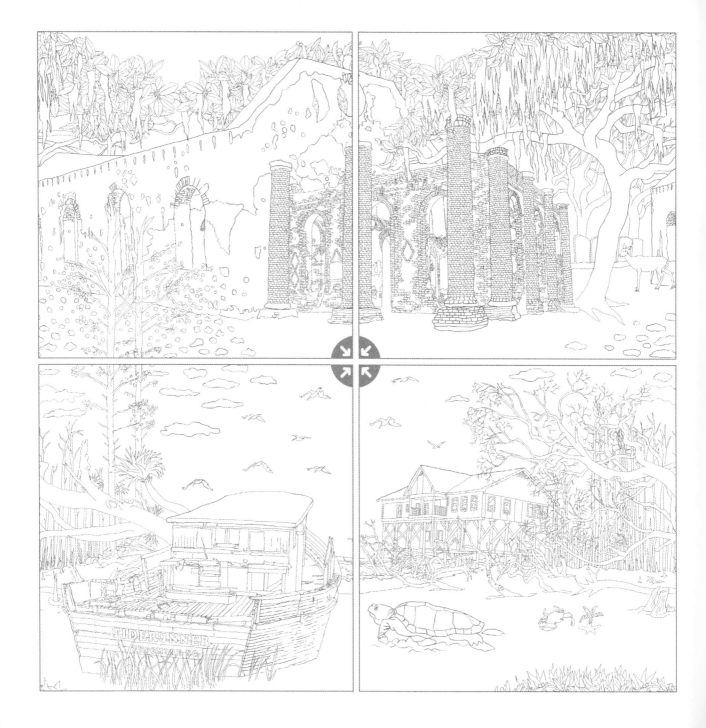

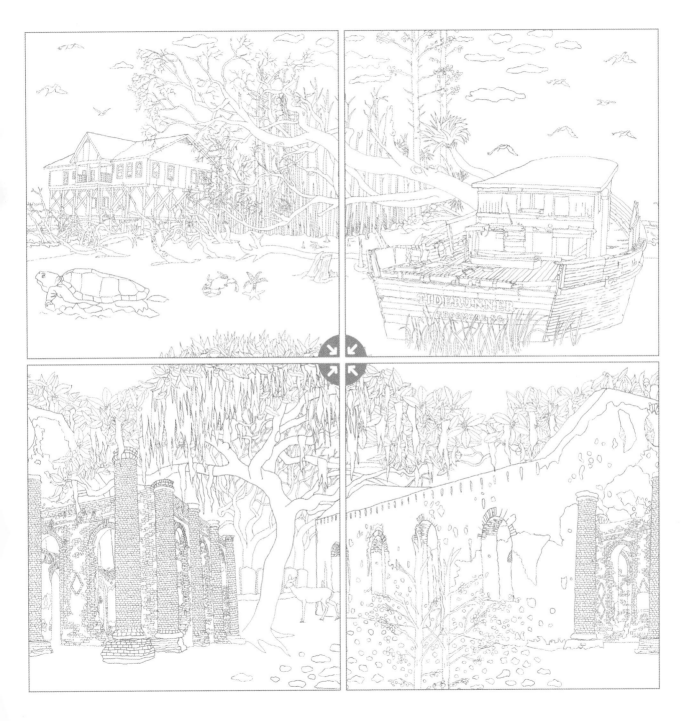

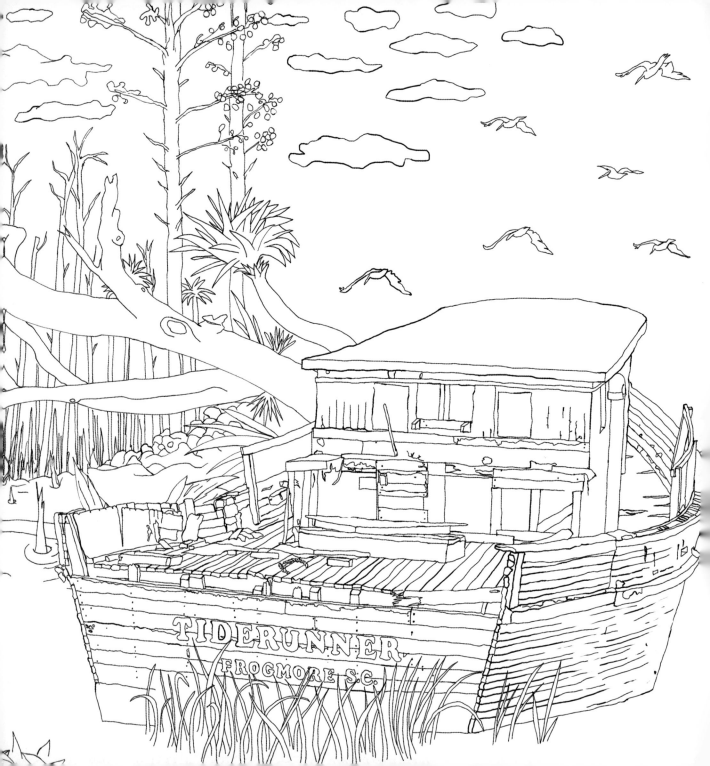

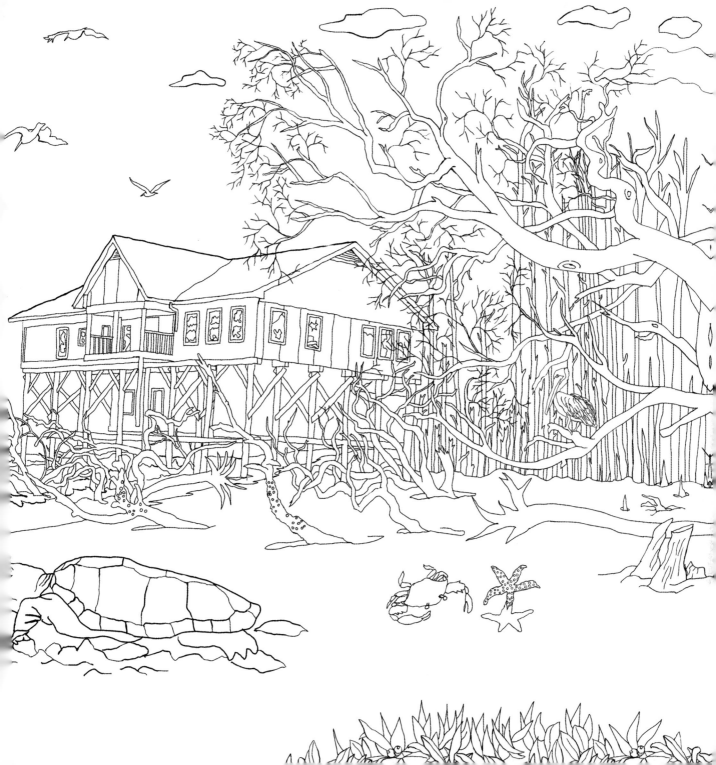

MELISSA CONROY was born in the South Carolina Lowcountry, and every summer she returns with sketchbook in hand. She has master's degrees from the University of Georgia and Philadelphia University in painting and textile design, and a BFA in painting from the Rhode Island School of Design. Currently she lives in Philadelphia with her husband, daughter, and son. She is a part-time faculty member in the Textile Design Department at Philadelphia University. Visit www.melissaconroy.com.